THE **ART**
PUZZLE
BOOK

First published in 2019 by White Lion Publishing,
an imprint of The Quarto Group,
The Old Brewery, 6 Blundell Street,
London, N7 9BH,
United Kingdom
T (0)20 7700 6700
www.QuartoKnows.com

© 2019 Quarto Publishing plc.

Text by Susie Hodge
Puzzles by Dr Gareth Moore
Edited by Nick Freeth
Designed by Sue Pressley and Paul Turner, Stonecastle Graphics Ltd

A catalogue record for this book is available from the British Library.

ISBN 978-0-7112-4816-8

10 9 8 7 6 5 4 3 2 1

Printed in China

Cover: copy after Mondrian © World History Archive/Alamy Stock Photo

THE **ART** PUZZLE BOOK

Susie Hodge & Dr Gareth Moore

WHITE
LION
PUBLISHING

Contents

PUSZLES 6

01 *Last Judgement of Hunefer from the Book of the Dead* 8
Unknown artist

02 *Crucifixion* 12
Altichiero da Verona

03 *January, from Les Très Riches Heures du Duc de Berry* 16
Limbourg brothers

04 *Adoration of the Magi* 20
Gentile da Fabriano

05 *The Arnolfini Portrait* 24
Jan van Eyck

06 *Primavera* 28
Sandro Botticelli

07 *The Garden of Earthly Delights* 32
Hieronymus Bosch

08 *Creation of Adam* 36
Michelangelo Buonarroti

09 *The School of Athens* 40
Raphael

10 *Bacchus and Ariadne* 44
Titian

11 *Netherlandish Proverbs* 48
Pieter Bruegel the Elder

12 *The Wedding Feast at Cana* 52
Paolo Veronese

13 *Akbar's Adventures with the Elephant Hawa'i* 56
Basāwan and Chetar Munti

14 *The Conversion of Saint Paul* 60
Michelangelo Merisi da Caravaggio

15 *A Winter Scene with Skaters near a Castle* 64
Hendrick Avercamp

16 *Judith Slaying Holofernes* 68
Artemisia Gentileschi

17 *Spring Morning in the Han Palace* 72
copy after Qiu Ying

18 *Las Meninas* 76
Diego Velázquez

19 *The Milkmaid* 80
Johannes Vermeer

20 *The Third of May 1808* 84
Francisco de Goya

21 *Ryōgoku Bridge and the* 88
Great Riverbank
Utagawa (Andō) Hiroshige

22 *The Artist's Garden at Vétheuil* 92
Claude Monet

23 *A Bar at the Folies-Bergère* 96
Édouard Manet

24 *A Sunday on La Grande Jatte* 100
Georges-Pierre Seurat

25 *The Starry Night* 104
Vincent van Gogh

26 *Portrait of Marie and Gilberte* 108
Suzanne Valadon

27 *Composition with Large* 112
Red Plane, Yellow, Black,
Grey and Blue
Piet Mondrian

28 *The Tilled Field* 116
Joan Miró

29 *Guernica* 120
Pablo Picasso

30 *Metamorphosis of Narcissus* 124
Salvador Dalí

31 *Rythme 38* 128
Sonia Delaunay

32 *Self-Portrait with Thorn* 132
Necklace and Hummingbird
Frida Kahlo

33 *Relativity* 136
M.C. Escher

34 *Skyway* 140
Robert Rauschenberg

35 *Furious Man* 144
Jean-Michel Basquiat

36 *Tree of Life* 148
Keith Haring

ANSWERS 152

Index 190

About the Authors and Picture Credits 192

PUZZLES

In this book you will be taken on a journey through art history, from ancient Egypt to 1980s New York, via thirty-six iconic works of art. Read the introductions to find out about each piece and the artist who created it, looking for clues in the text along the way.

You'll then encounter a set of puzzles relating to the painting, each designed to encourage you to look at the artwork more closely. Entertaining, and all different, the puzzles will test your powers of observation and general knowledge: challenging you to hunt for things, interpret symbols, seek out colours and decipher cryptic clues.

Tackle the puzzles on your own or with friends, and in any order you like. Some are straightforward, but others will require more thought and closer scrutiny – so that you'll want to turn back the pages and discover things you may have missed.

Hieroglyphs – the word derives from the Greek for 'sacred carving' – were central to the Egyptian use of magic and were believed to have been created by the god Thoth.

01

Last Judgement of Hunefer from the Book of the Dead
Unknown artist

c.1285 BCE

Papyrus

British Museum, London, UK

Royal Scribe, Overseer of Royal Cattle and the steward of Pharaoh Seti I, Hunefer lived in Egypt in around 1310 BCE. In this section of the Papyrus of Hunefer, his richly illustrated copy of the Egyptian Book of the Dead, his soul is being judged to see if he is worthy enough to enter the afterlife. In part of this scroll, he kneels before a court of gods, explaining that he has lived a good life. Below, he is led by the jackal-headed god Anubis to the scales. Anubis weighs his heart against the Feather of Truth (from the goddess Ma'at), while the goddess Ammit, the 'Devourer of the Damned', waits. If Hunefer's heart is heavy with sin, Ammit will eat it. To the right, ibis-headed Thoth, the god of wisdom, knowledge and writing, is ready to record the outcome of the weighing. Finally, Hunefer has passed the test and is led by the falcon-headed Horus to Osiris, who sits on his throne accompanied by the goddesses Isis and Nephthys.

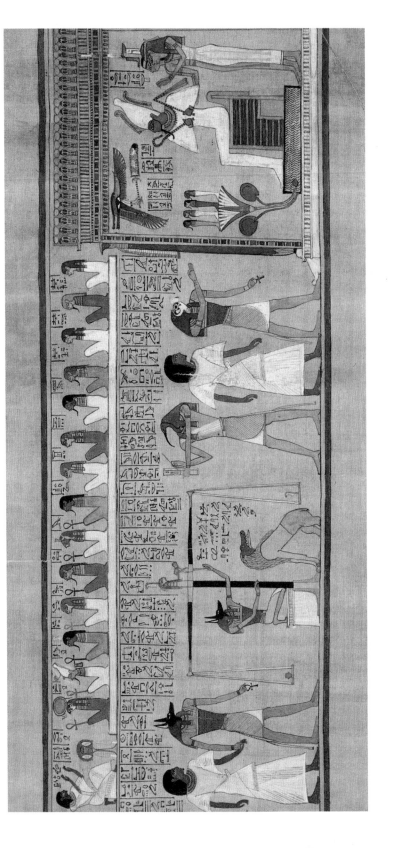

In the Picture

1 The image on the right shows an ankh, the Egyptian symbol of life. How many ankhs can you count in the picture, ignoring any in the hieroglyphs?

2 There are a large number of eyes in the picture, but how many aren't on characters with human faces or human legs? An item counts as an eye for the purpose of this question if there is clearly an outer eye and an inner pupil.

3 How many figures in the picture *don't* have human hands?

General Knowledge

These three questions can be all be solved by carefully observing the picture.

4 How many times is Anubis, the god of the dead, shown? What is he holding in each case?

5 The 'Devourer' is a strange beast that can condemn a dead person to non-existence. It is shown in this picture, and is part-lion, part-hippopotamus and part what other animal?

6 Hunefer is shown three times in this picture. Can you identify where he appears?

The earliest known
depiction of the Crucifixion is a
satirical representation of a donkey on
a cross known as the Alexamenos graffito.
It is thought to date back to c.200 CE
and was most likely scratched in the
plaster by a Roman mocking
Christian worship.

02

Crucifixion
Altichiero da Verona (1330–1390)
c.1376–84
Fresco
Oratorio di San Giorgio, Padua, Italy

Assisted by the Bolognese painter Jacopo Avanzi (1350–1416), Altichiero created several frescoes in the Oratorio di San Giorgio in Padua, Italy. Using different scales and proportions to create his own form of perspective, here Altichiero also features some human qualities and gestures that Giotto (1267–1337), the influential Italian painter, had recently introduced. It is a busy scene, and Altichiero's depictions of figures and animals, facial expressions, details such as the grain of the wood and angles of the crosses; soft, pale highlights and darker shadows conveying natural light; draping fabrics; realism; rhythm and harmony, were all original and sophisticated for the time. High on the cross, Jesus appears to accept his fate serenely, while below and around him, angels, friends, followers and his mother lament. Mary has fainted in grief and some of the soldiers appear to be beginning to wonder what they have done.

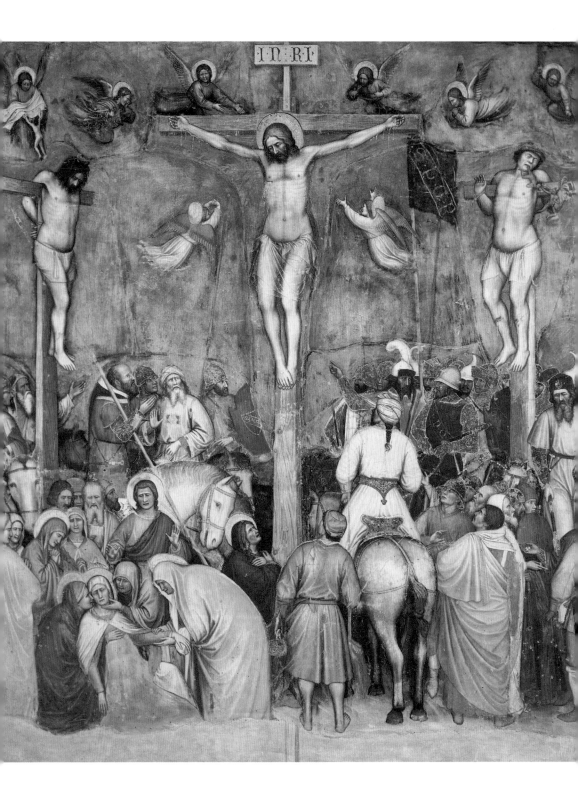

In the Picture

1 How many haloes can you count?

2 How many miniature figures can you see in the sky?

3 How many times do the initials SPQR (or part of them) appear?

4 How many figures are looking at Mary?

Visual Matching

See if you can find these details in the painting:

5 6 7

General Knowledge

8 There are four written letters above the crucified Christ. What do those initials mean?

9 What do the initials SPQR stand for?

Soldiers on a tapestry in the background signify the war being fought at the time by the French against King Henry V of England.

In the inner semicircle at the top, the figure holding the sun in his hands is probably a depiction of Helios, the sun god. In Greek mythology, Helios drove the sun across the sky using a horse-drawn chariot.

03

January, from *Les Très Riches Heures du Duc de Berry*
Limbourg brothers (c.1385–1416)

c.1412–16
Gouache and gold leaf on vellum
Musée Condé, Chantilly, France

The most famous surviving example of French International Gothic manuscript illumination, this calendar page depicting January comes from a Book of Hours – a personal prayer book commissioned by the extremely wealthy Duke of Berry. It was made by the highly skilled Dutch miniature painters, brothers Herman, Paul and Jean de Limbourg. Following a tradition of exchanging gifts to celebrate the New Year, here the Duke of Berry presides at a table laden with presents. He is dressed in bright and costly blue and gold, while the man in the grey cap leaning against the front of the table is possibly a self-portrait of Paul de Limbourg. The expensive cloth and lavish gifts convey the Duke's prosperity and taste, while around the image are heraldic motifs relating to him, such as the gold fleur-de-lis, which links him to France. At the top left of the picture is January's astrological sign, Capricorn, included because the agricultural calendar, and much of medieval medicine, were influenced by the phases of the moon and the astrological zodiac.

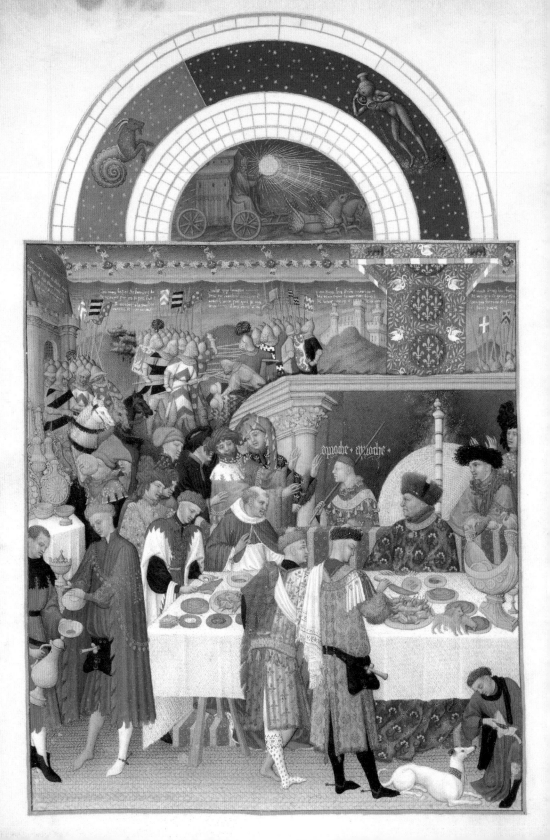

In the Picture

1 How many horse's heads can you see?

2 How many banners can you count?

3 How many different types of animal can you find in the picture, excluding the meat on the table?

General Knowledge

4 Where would you originally have found this illustration?

5 The Limbourg brothers are credited with the original work. How many others are thought to have contributed to it?

6 What is the function of the black belt wrapped around the outside of the men's robes?

Visual Matching

Can you find the following visual details in the painting?

7 **8** **9**

The women whispering behind the Virgin are expensively dressed midwives.

Gentile applied gold leaf beneath layers of paint, to create a shimmering glow when seen in candlelight.

04

Adoration of the Magi
Gentile da Fabriano (c.1370–1427)
1423
Tempera on panel
Galleria degli Uffizi, Florence, Italy

In the Bible, it is recounted how the educated, noble and wealthy Magi ('Wise Men') travelled 'from the east' to visit Jesus after his birth, bearing gifts of gold, frankincense and myrrh. The Bible does not specify how many Magi there were. Historically, they usually travelled in groups of twelve or more, with at least one hundred soldiers, but western Christianity traditionally refers to three. This painting comprises several scenes in one to show the Magi's journey as they follow the star to Bethlehem. Gentile da Fabriano depicts them stopping at Herod's palace, visiting the baby bearing their gifts, and finally returning home. In magnificent costumes made from materials such as brocade and gold thread, they travel with an exotic entourage comprising various individuals, dogs, apes, lions, a leopard, a dromedary, birds and horses. In the foreground, they kneel before the Holy Family. Here and there, Gentile has embossed metal leaf to create raised textures, such as on a horseman's spurs, the hilt of a sword and on crowns, haloes and the holy gifts.

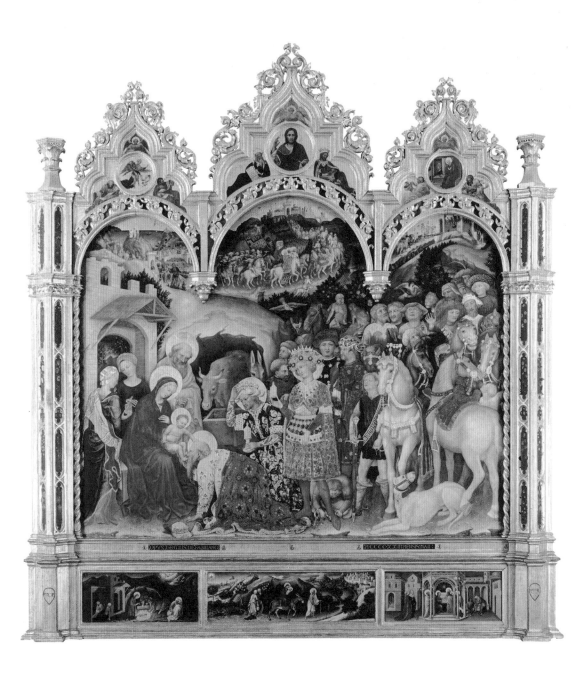

In the Picture

1 How many people or angels holding ribbons can you find?

2 Can you find the heads of both a leopard and a lion in the painting?

3 How many times do the Magi appear in the picture?

Visual Matching

See if you can find the following details in the painting:

4 5 6

General Knowledge

7 Symbolically, what do the ox and donkey just behind the infant Jesus represent?

8 Which city is depicted at the top of the centre of the painting?

9 And which town is shown at the top right of the painting?

Van Eyck was
one of the first artists to
use oil paint, and his
handling of it was
revolutionary.

Painted on the wall
below the mirror are the
words: 'Jan van Eyck was
here 1434' – written
in Latin.

05

The Arnolfini Portrait
Jan van Eyck (c.1390–1441)

1434
Oil on oak panel
The National Gallery, London, UK

This small, meticulously painted portrait depicts Giovanni di Nicolao Arnolfini and either his late wife Costanza Trenta (who had died by the time the painting was completed), or his second wife, Giovanna Cenami, whom he married three years later. One of the first merchant bankers, Arnolfini came from a prosperous Italian family. As was fashionable in northern Europe at this time, this painting is filled with details and symbols, including the dog representing fidelity. Note how Arnolfini's shoes point towards the outside world while the woman's point into the home. Despite outward appearances, the woman is not pregnant, but holding up her heavy, fashionable and costly dress. The room contains evidence of wealth and religious faith. Only the rich could afford mirrors, and the frame on this one features scenes from the Bible, while elsewhere can be seen a crucifix and a type of rosary. Arnolfini raises his hand to greet a couple reflected in the mirror; one may be the artist himself.

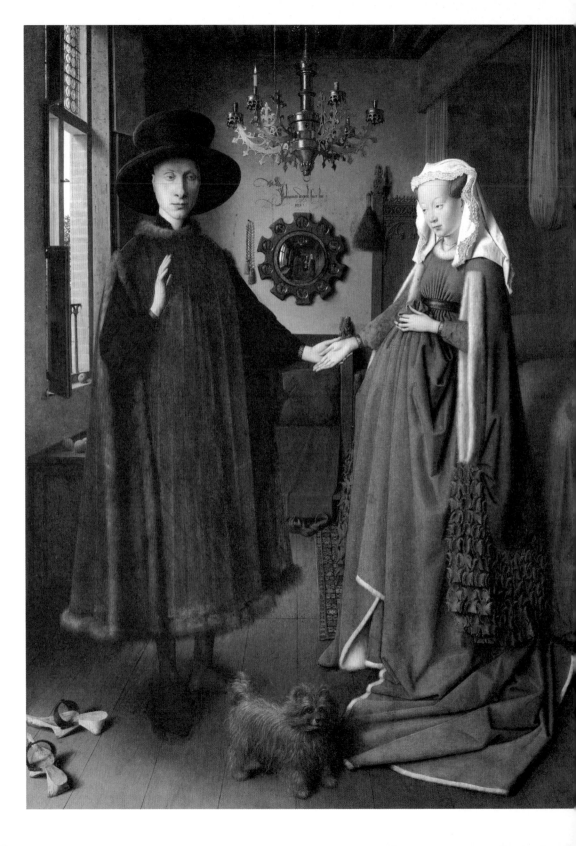

In the Picture

1 How many pairs of loose footwear can you count?

2 Can you find a symbol of fidelity in the picture?

3 How many different people are shown in the portrait?

4 In what three places can you find an alternating red and blue colour pattern?

General Knowledge

5 In which city is it thought that the room was located?

6 Can you spot seven indicators of wealth?

7 The amber beads on the wall are a specific form of rosary: what is it called?

Cryptic Clues

Each of these cryptic crossword clues refers to an item in the picture. Can you solve them?

8 God returned with animal (3).

9 Nose rag shaken for this produce (7).

10 Candle spread across heir's light fixture (10).

Botticelli requested to
be buried near the muse who
inspired his Venus, Simonetta Vespucci,
a married noblewoman for whom
it was rumoured he harboured
unrequited love.

Botticelli remained relatively
unknown for centuries after his death
until *The Birth of Venus* was included in a
travelling exhibition organised by Benito
Mussolini in the 1930s. The painting became a
huge hit, but the main reason it was chosen
was because the large canvas could be
rolled and transported easily.

06

Primavera
Sandro Botticelli (1445–1510)

c.1478

Tempera on panel

Galleria degli Uffizi, Florence, Italy

Venus, the goddess of love and beauty, stands in a garden. Above, her son Cupid shoots his arrow. Zephyrus, the god of the west wind, blows a gentle breeze while chasing the nymph Chloris who transforms into Flora, the goddess of spring. This is indicated by flowers coming out of Chloris's mouth. Nearby Hermes (or Mercury), the messenger god, moves the winter clouds away. With their alabaster skin, long fingers and softly rounded bellies, the Three Graces (the daughters of Zeus) symbolise the beauty and fertility of spring, and also represent the 'feminine' virtues of chastity, beauty and love. All the characters in the painting are linked with spring in classical mythology and portray ideals of Neoplatonism, especially physical, spiritual and platonic love. Botticelli drew inspiration from classical and contemporary poets, including Ovid, Lucretius and Poliziano, and he created the painting to resemble the Flemish tapestries that were popular palace decorations at that time.

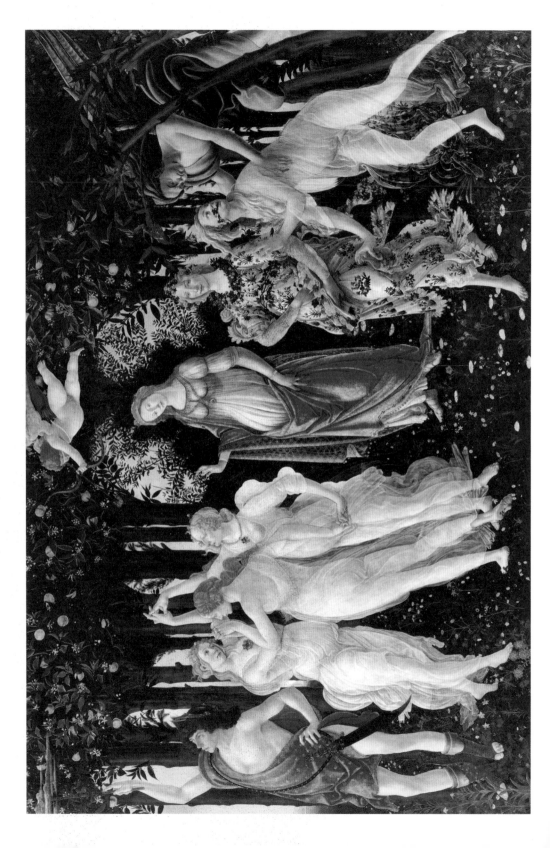

In the Picture

1 Which character is blindfolded, and why?

2 What is Flora doing, just to the right of Venus?

3 Where can you find a being whose name literally means 'a soft gentle breeze'?

Visual Matching

See if you can find the following details in the painting:

4 5 6

General Knowledge

7 What are the Three Graces doing?

8 Why are oranges said to have been a symbol of the Medici, who are thought to have commissioned the painting?

9 Who was the Greek equivalent of Venus?

10 Which two women represent the same person?

When Bosch was thirteen, his home town Den Bosch was struck by a disastrous fire, which some say inspired the depictions of burning buildings in his paintings.

Historians don't know much about Bosch, but his first name has been recorded as Hieronymus, Jheronimus, Jeroen, Jerom and Jerome.

07

The Garden of Earthly Delights
Hieronymus Bosch (c.1450–1516)

1500

Oil on oak panel

Museo Nacional del Prado, Madrid, Spain

Some read this painting as a warning about the transience of earthly pleasures and the consequences of living a sinful life, while others believe that it is a panorama of paradise lost. *Earthly Delights* is a modern title that was given to describe the huge image swarming with nudes, exotic animals, strange creatures and enormous birds and fruit. There are no babies, children or old people in the painting, and many of the naked men and women are participating in diverse activities. There is no logic, as proportions, perspective and normal behaviour are all confused. Red represents passion and the pleasures of the flesh, and is here illustrated by giant strawberries, blackberries and raspberries. In the centre is a pool, full of bathing women, while men on horses ride around it – one of the many sexual metaphors within the scene. Overall, the image appears to convey a warning to those who indulge in folly and sin during their earthly lives.

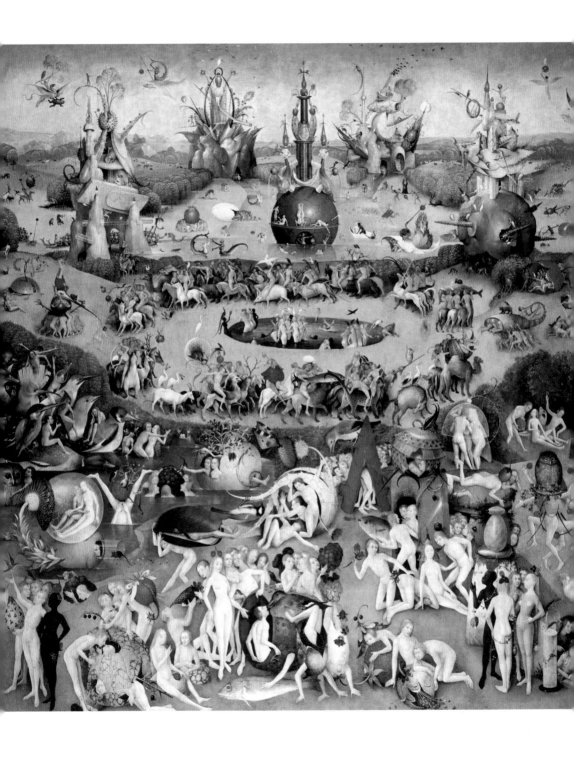

In the Picture

1 Can you find a figure hugging an owl?

2 There is a colourful kingfisher in this painting. Can you find it?

3 Can you find three giant strawberries?

Visual Matching

Can you find the following elements in the picture?

4 **5** **6**

Cryptic Clues

Which creatures in the picture are being hinted at by the following clues?

7 Insect left by rut is confused (9).

8 Zero score for a foul, it's said (4).

9 And which creature do you think this number sequence might be abstractly hinting at (3)?

2 8 2 8 2 0

Michelangelo was hot-tempered, devoted to his profession and rarely satisfied with his work. In 1509 he wrote of the painstaking torture he suffered in painting the Sistine chapel: 'I live in Hell and paint its pictures'.

It is thought by some that, in an act of jealousy, Raphael persuaded Pope Julius II to commission Michelangelo to paint the ceiling: Michelangelo had never painted a fresco and was bound to fail. How wrong Raphael was.

08

Creation of Adam
Michelangelo Buonarroti (1475–1564)

1508–12

Fresco

Sistine Chapel, Vatican City, Rome, Italy

Here, in the most famous section of the Sistine Chapel
ceiling, God is creating the first human. With grey hair and
a long beard, this gentle God of Michelangelo's invention
contrasts dramatically with traditional, dominating images
of him. However, the light pink chemise he wears was
painted by a later artist. God leans towards the physically
perfect Adam, who languidly extends his left arm towards
him. The space between Adam's and God's fingers helps
to convey the energy and dynamism of the moment. Both
figures are strong and statuesque, their gestures and
mannerisms relaxed and natural. God floats within a shape
made of drapery, supported by angelic figures who fly
without wings. Some have speculated that the fabric shroud
surrounding God has the shape of a human brain, which
suggests that he was endowing Adam with intelligence as
well as life: it is the birth of the human race.

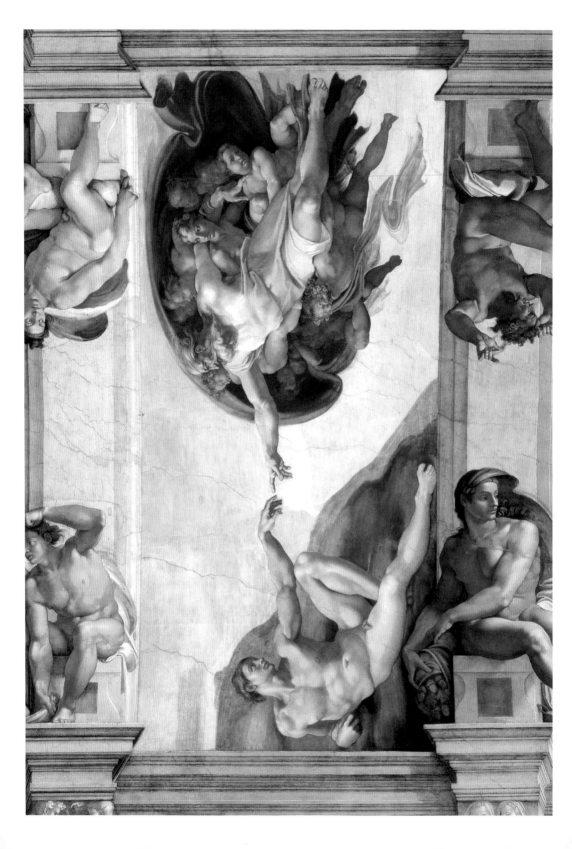

In the Picture

1 How many hands can be seen in the picture?

2 How many women can be seen?

3 How many figures are pictured surrounding God?

Visual Matching

Can you find these visual details in the picture?

4 **5** **6**

General Knowledge

7 In which famous building is the painting located, and whereabouts?

8 Why is God wearing a pink robe?

9 What part of the human anatomy do some argue that the red shroud represents?

It is commonly believed
that Raphael included a number
of his contemporaries in the painting.
For example, Euclid (or Archimedes),
bending forward with a compass, is
a portrait of the architect
Donato Bramante.

Raphael is often considered
the high point of Renaissance art.
His work was so refined that a group of
rebellious ninetenth-century English artists
based their whole ethos on looking back
to a time before Raphael. They were
called the Pre-Raphaelites.

09

The School of Athens
Raphael (1483–1520)

1509–11

Fresco

Stanza della Segnatura, Vatican, Rome, Italy

In 1509, Raphael began decorating rooms in the Papal Palace in Rome. On each wall, he painted a theme to reflect that room's business. This is one of his frescoes in the Stanza della Segnatura, the Pope's library where important documents were signed. Representing philosophy, it depicts great men from different periods in history, including Plato and Aristotle, Alexander the Great, Pythagoras, Socrates and Ptolemy. Probably modelled on Michelangelo, the figure on the steps resting his headon his hand represents the ancient Greek philosopher Heraclitus, while Raphael painted his own self-portrait peering out between figures on the extreme right. Surrounding the group, he depicted magnificent, classical architecture, inspired by his friend, the Pope's architect Donato Bramante, and his recent work on the new Saint Peter's Basilica nearby. Raphael's interior follows the shape of a Greek Cross. On either side of the great arch are statues of Apollo, the Greek and Roman god of light, archery and music, and Minerva, the Roman goddess of wisdom.

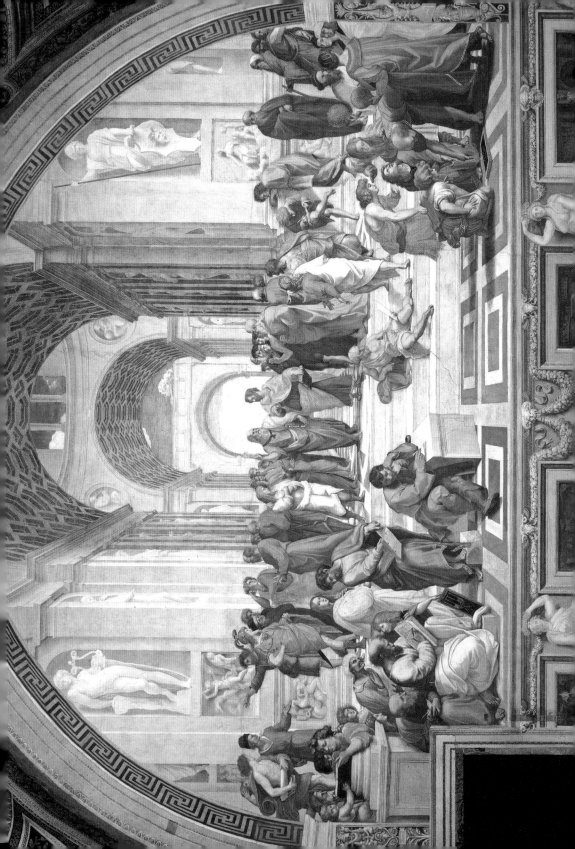

In the Picture

1 Plato can be seen pointing to the sky. Where is he?

2 Can you locate Pythagoras, dressed in white and pink?

3 There is a musical instrument in the picture. Can you spot it?

4 Can you find two brown sticks?

5 There is a compass in the picture. Where?

General Knowledge

6 Whose face and physique is Raphael thought to have used for Plato?

7 What book is Plato holding?

8 Standing next to Plato, and pointing forwards, what book is Aristotle holding?

Visual Matching

Can you find these details in the picture?

9 **10**

During his career Titian was so highly esteemed that he was described as 'The Sun Amidst Small Stars'.

Traditionally, leopards pulled Bacchus's chariot, but Titian painted the Duke of Ferrara, Alfonso d'Este's pet cheetahs as a compliment to the patron of this particular work.

10

Bacchus and Ariadne
Titian (c.1488–1576)

c.1520–23
Oil on canvas
The National Gallery, London, UK

Recognised for his experimentation with many different painting styles, Titian used brilliant colours, complex compositions and fluid brushwork to convey clear light and dynamism. This painting illustrates a mythological story told by the ancient Roman poets Catullus and Ovid. Princess Ariadne, the daughter of the King of Crete, had fallen in love with Theseus – one of the greatest mythical Greek heroes – and helped him to kill the Minotaur in the labyrinth at the Palace of Knossos. However, Theseus heartlessly abandoned her while she slept on the island of Naxos. Here, a heartbroken Ariadne has awoken to see Theseus's ship sailing away in the far distance, just as Bacchus, the lively, fun-loving god of wine, comes along with his rowdy entourage of mythical creatures and animals. The moment he sees her, Bacchus falls instantly in love with Ariadne and leaps from his chariot. Similarly, when she sets eyes on Bacchus, Ariadne forgets Theseus in a moment.

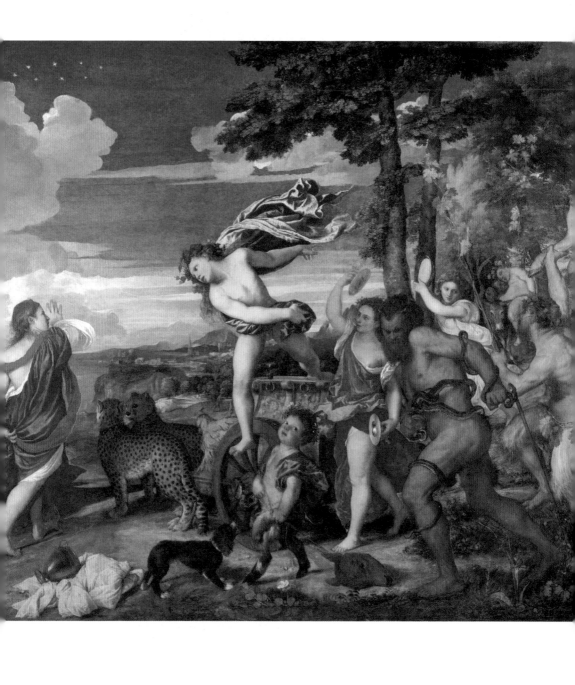

In the Picture

1 How many separate pieces of cloth can you count in the painting?

2 How many living animals can you see in the foreground?

3 How many characters with entirely human figures can be counted?

4 How many musical instruments are in the painting?

Visual Matching

Can you find the following details in the painting?

5 **6**

General Knowledge

7 Which famous artist completed a preliminary drawing for this painting, before his death led to Titian being commissioned instead?

8 What do the eight stars at the top left represent?

9 Why is Bacchus leaping out of the chariot?

Pieter Bruegel the Elder
was the head of what was to become
a great dynasty of Bruegel artists that lasted
over 200 years. One of his sons, Pieter Bruegel
the Younger, specialised in making commercial
copies of his father's work, including
a very convincing version of
Netherlandish Proverbs.

11

Netherlandish Proverbs
Pieter Bruegel the Elder (c.1525–69)

1559
Oil on oak panel
Gemäldegalerie, Staatliche Museen zu Berlin,
Berlin, Germany

When gathering material for his paintings of peasant
life, Pieter Bruegel the Elder would sometimes dress in a
poor man's clothing in order to mingle more easily with
his subjects. His depictions of peasants were original,
usually humorous or moralising, and they became highly
influential. During his lifetime, most ordinary people
were superstitious and fearful of the unknown and the
unexplained. Many books and prints featuring illustrations
of well-known proverbs were sold. This painting looks
down on a scene that is crammed with individuals and
groups illustrating more than one hundred of the most
popular sayings of the time. Images like this, filled with
tiny figures involved in different incidents, were called
Wimmelbilder and people loved them, often seeing them
in the form of prints. Overall, the work depicts human folly,
and contemporary viewers would have enjoyed spotting
the featured proverbs and relishing Bruegel's vivid visual
interpretations of them.

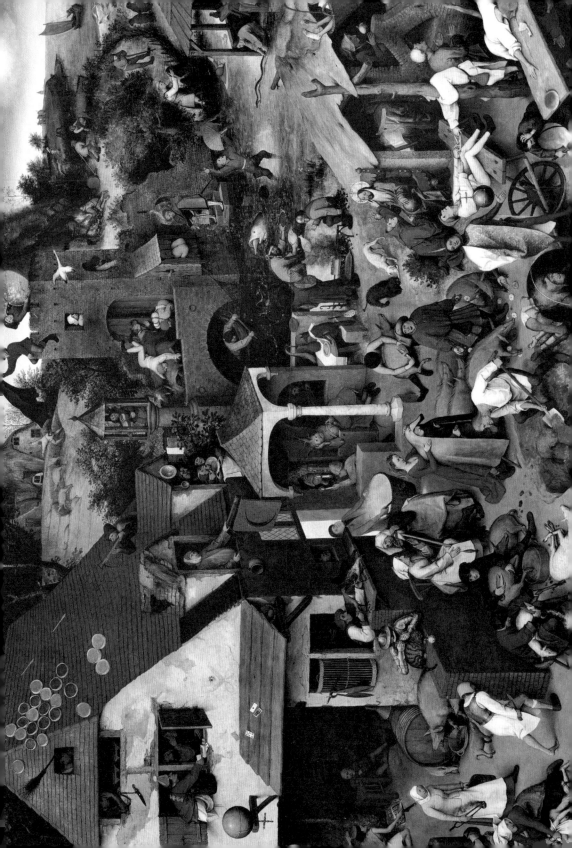

In the Picture

Can you find the following Flemish proverbs in the picture?

1 To bang one's head against a brick wall. (To strive for something in the face of insurmountable obstacles.)

2 The whole world is turned upside down. (The regular order of things has been upset or reversed.)

3 To be armed to the teeth. (To be fully prepared or equipped.)

4 It is easy to sail before the wind. (Things require little effort when you're going along with prevailing trends and forces.)

5 It is unwise to swim against the current. (Conversely, when you oppose prevailing trends or opinions, life will be harder.)

6 He who has spilt his porridge cannot scrape it all up again. ('Don't cry over spilt milk' – it's fruitless to dwell on a mistake or accident that can't be altered.)

7 To cast roses before swine. (To waste valuable things on people who can't appreciate their worth.)

8 Two dogs over one bone seldom agree. (People are unlikely to settle their differences when they're both after the same thing.)

9 To sit on hot coals. (To be impatient and restless.)

As well as the extremely costly blue pigment derived from lapis lazuli, here Veronese also uses the cheaper blues of azurite and smalt.

In 1797 Napoleonic soldiers stole *The Wedding Feast at Cana* from the refectory of the church of San Giorgio Maggiore in Venice. To transport the gigantic canvas to the Louvre, they cut it up into sizeable pieces that could easily be rolled.

12

The Wedding Feast at Cana
Paolo Veronese (1528–88)

1562–63
Oil on canvas
Musée du Louvre, Paris, France

Paolo Caliari, known as Veronese, was born in Verona, but based himself in Venice. He became famous for his large-scale paintings – which are dramatic, with majestic architectural settings, skilful foreshortening, vivid colouring, exuberant light effects and lively pageantry. This one depicts the New Testament story of the Wedding Feast at Cana. Jesus and his mother were guests at a wedding when the wine ran out, so he miraculously turned water into wine. Veronese's depiction of the story is busy and bright, set against Classical architecture. In the foreground, musicians play; they are all portraits of Venetian artists, including Veronese himself, Titian, Tintoretto and Jacopo Bassano. In between his apostles, Jesus looks directly at the viewer. He and the Biblical figures are dressed simply, while the other wedding guests are in contemporary finery. All around, people are noticing that their water has turned to wine, including a man (modelled by Veronese's brother) examining his glass, and a servant pouring some into a flagon.

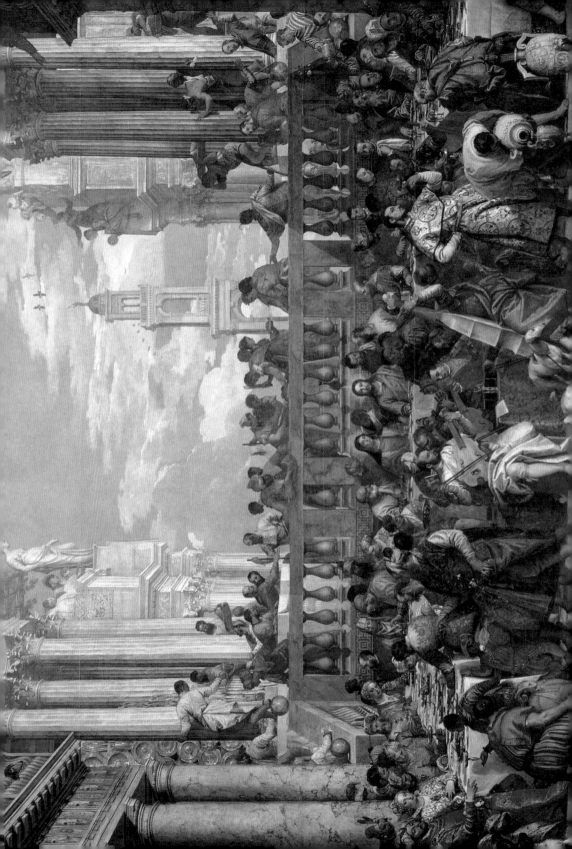

In the Picture

1 Can you find someone cleaning his or her teeth with a toothpick?

2 Where is the bridegroom?

3 Can you locate two people looking at glasses of wine in their hands?

Visual Matching

Find these details in the picture:

4 **5** **6**

General Knowledge

7 Why is lamb shown being prepared in the centre of the picture even though the guests have moved on to their dessert course?

8 Which figure is the steward of the house?

9 What is special about the size of this painting?

This is part of
the Akbarnama – the
official chronicle of Akbar's
reign, written in Persian
and illustrated by
royal artists.

Basāwan was an
innovative miniature painter
and skilled colourist who created
lively images, often from unusual
viewpoints, and portraits. However,
he probably only drew the
outlines for this one.

13

Akbar's Adventures with the Elephant Hawa'i

Basāwan (fl.1580–1600) and Chetar Munti (dates unknown)

c.1590–95

Opaque watercolour and gold on paper

V&A Museum, London, UK

The painting tells an allegorical tale about an incident in the life of the Indian emperor Akbar I, known as Akbar the Great (r.1556–1605). The grandson of the founder of the Mughal dynasty in India, Akbar was thirteen years old in 1556 when he killed Hemu, a rebel nobleman who had declared himself ruler of Delhi. The event depicted here took place outside the fort of Agra, five years after Akbar became emperor. The royal elephant Hawa'i was especially strong and most men could not ride him, but Akbar mounted him with ease and pitted him against an equally fierce elephant named Ran Bagha. Akbar is shown on the back of Hawa'i, pursuing Ran Bagha across a bridge of boats that crosses the River Jumna, and which collapses under the weight of the elephants. Several of Akbar's servants have jumped into the water to escape the stampeding animals.

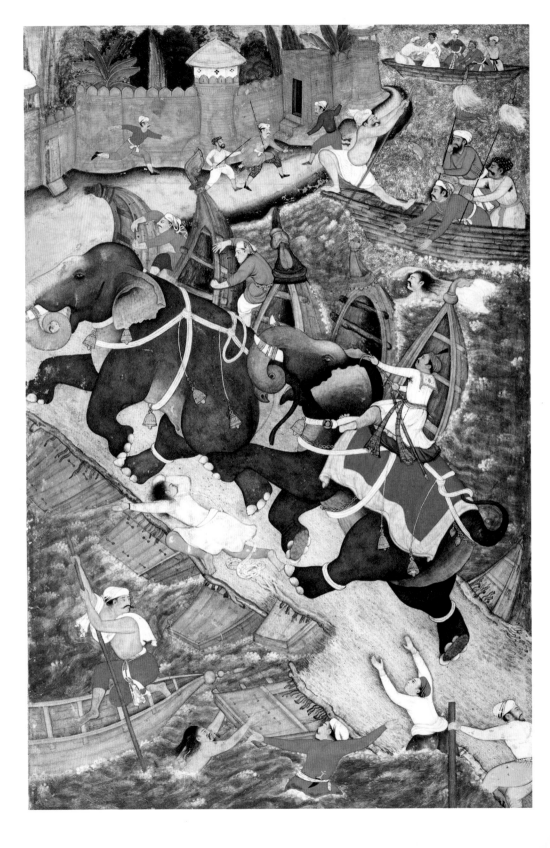

In the Picture

1 How many boats form part of the pontoon bridge?

2 How many bell decorations hang from the two elephants?

3 How many people can you see in the painting?

General Knowledge

4 Why is this image credited to two artists?

5 Which figure is likely to depict the emperor Akbar the Great, and why?

6 How old was Akbar the Great when he was proclaimed emperor?

Cryptic Clues

Each of these cryptic crossword clues refers to an item in the picture. Can you solve them?

7 Skate, perhaps, in surf is hopeless (4).

8 Top prelate exchanges leader for river stay, maybe (4).

9 He's crossing the main southwestern one-mile French sea (7).

Caravaggio is well known
for being a colourful and controversial
character. In 1606 he killed a young man ,
Ranuccio Tomassoni, in a duel in Rome.
His patrons could not protect him
and he fled to Naples, before
making his way to Malta
and Sicily.

14

The Conversion of Saint Paul
Michelangelo Merisi da Caravaggio
(1571–1610)

1601

Oil on canvas

Odescalchi Balbi Collection, Rome, Italy

Thrown onto his back, Saint Paul (as he will later be known) clutches at his eyes. A notoriously cruel persecutor of Christians in Jerusalem, he had been on his way to Damascus to continue his campaign there, when he was surrounded by a 'light from heaven'. Falling to the ground, he heard Jesus's voice asking, 'Why are you persecuting me?' While helpless and vulnerable, he realised how wrong his former actions had been; the incident converted him to Christianity. To convey the full extent of what has overtaken him, his horse and other figures are included, adding to the scene's confusion; but while light touches them here and there, it is only Paul who is bathed in Heaven's powerful light. Using unexpected angles, dramatic foreshortening, large figures and strong light and dark contrasts, Caravaggio compels viewers to focus on the action, and to consider the illuminated man whose armour has fallen from him, as he is temporarily blinded.

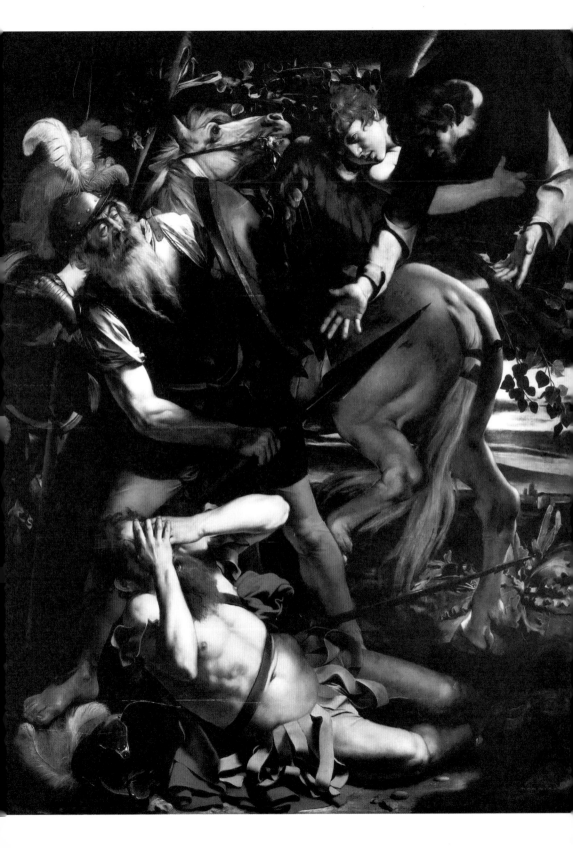

In the Picture

1 How many helmets can you count in this picture?

2 Who do you think the figure in the top right corner of the image is supposed to be?

3 Why might the figure on the ground be covering his eyes?

Visual Matching

Can you find the following elements in the picture?

4 **5** **6**

General Knowledge

7 How was Saint Paul referred to prior to his conversion?

8 Why do you think Saint Paul is pictured wearing so few clothes?

9 What is the art term for the dramatic contrast of light and shade for which Caravaggio is known?

Avercamp used the
technique of aerial perspective,
creating a sense of depth by means
of cooler colours and fewer
details in the distance.

15

A Winter Scene with Skaters near a Castle
Hendrick Avercamp (1585–1634)

c.1608–09

Oil on oak

The National Gallery, London, UK

Deaf and mute, Hendrick Avercamp worked during the Dutch Golden Age, and became famous for his paintings of people relishing the extreme icy winters of the period. In this circular composition, it seems that everyone is out enjoying the crisp, chilly weather. Hundreds are on the frozen canal that recedes far into the distance under the pale winter sky. There is no single focal point and no social hierarchy; rich, poor, old and young all have the same prominence. If you look closely around the scene – as contemporary viewers loved to do – you will see people skating, sliding, falling over, becoming amorous and even relieving themselves. Some are opulently dressed, some hold hands, some skate confidently, while others are more tentative. A gilded carriage is pulled across the ice and children play. Although full of carefully observed details, including many of the individuals and the silhouetted tree, the actual scene with its castle is imaginary.

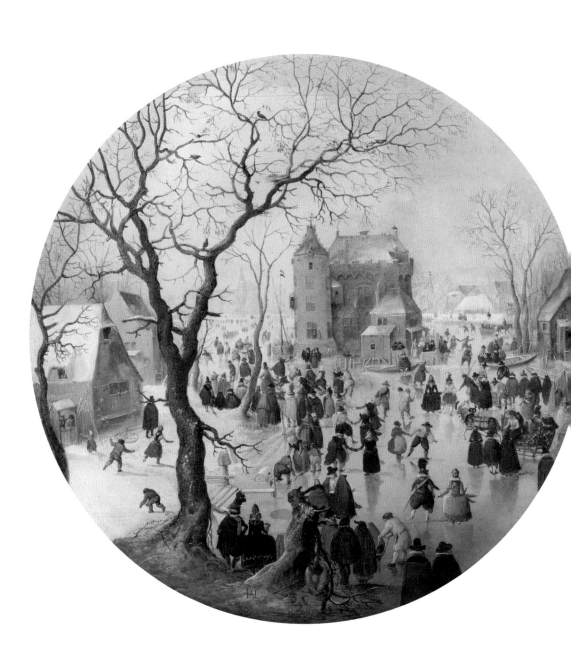

In the Picture

1 How many feathers is the sleigh-horse wearing?

2 Can you find a gentleman helping a lady with her skate?

3 What colour of clothing is worn by the woman who's pictured falling over?

Visual Matching

Can you spot the following details in the picture?

4 **5** **6**

General Knowledge

7 Why is the flag that is flying coloured orange, white and blue?

8 At one point in time, this was a square canvas. Why do you think it is now a circle?

9 What ultimately influenced Dutch artist Hendrick Avercamp to paint this snowy scene?

In 1611 Artemisia was
raped by her tutor, Agostino Tassi.
Her father, Orazio, pressed charges when
Tassi refused to marry her, and during the
seven-month trial it was also discovered
that Tassi had engaged in adultery with
Orazio's sister-in-law and planned
to murder his wife.

16

Judith Slaying Holofernes
Artemisia Gentileschi (1593–c.1656)

1611–12

Oil on canvas

Museo Nazionale di Capodimonte, Naples, Italy

Artemisia Gentileschi was unusual in being a female painter at a time when women rarely had careers. Heavily influenced by her artist father Orazio and Caravaggio, she defied convention and became one of the leading painters of the period, patronised by the powerful Medici family and King Philip IV of Spain. Her lifelike, dramatic and expressive paintings often portray strong women from myth and the Bible. Here, the Biblical heroine Judith is shown beheading Holofernes, the Assyrian general of King Nebuchadnezzar who had laid siege to Judith's city, Bethulia. When Holofernes met Judith, he invited her to his tent intending to seduce her, but then passed out in a drunken stupor. Taking her chance and assisted by her maid, Judith decapitated him. Here Holofernes is waking, still drunk, realising what is happening to him, but it is too late to fight off the women, while Judith grips his hair and saws at his neck.

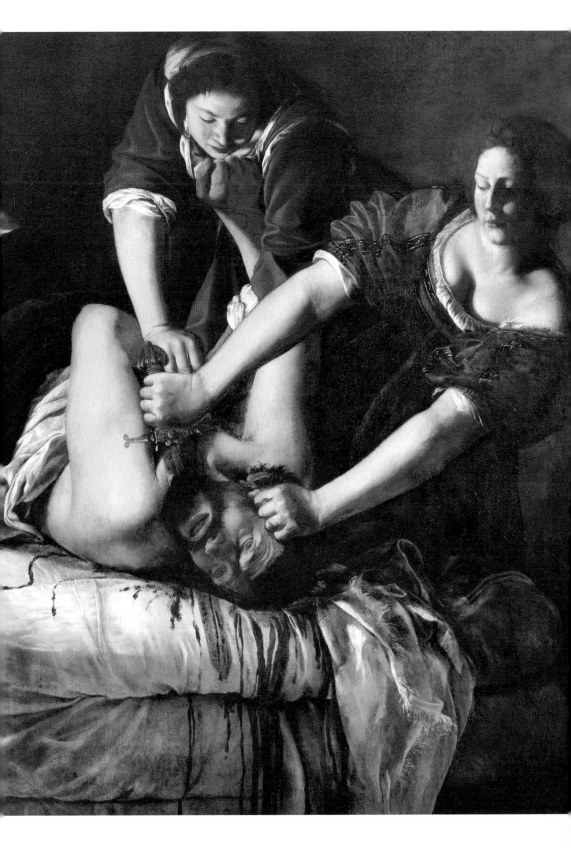

In the Picture

1 What colour is the detailing on Judith's dress?

2 On what does Holofernes lie?

3 Is Holofernes unconscious in the image?

Visual Matching

Can you spot the following details in the picture?

4 **5** **6**

General Knowledge

7 What is the name of the technique that Gentileschi has used in this painting that shows the influence of Caravaggio?

8 Whose face is the image of Judith based upon? And whose features do those of Holofernes resemble?

9 According to the Biblical story, what did Judith hang on the battlements to frighten the Assyrian army?

Although it depicts the Han Dynasty (206 BCE–220 CE), Qiu Ying has included fabric prints and objects from his own time during the sixteenth century.

Qiu Ying was commissioned by a renowned art collector, Hsiang Yuan-pien, to help re-establish China as a country celebrated for its culture.

17

Spring Morning in the Han Palace
copy after Qiu Ying (1494–1552)

after 1650
Ink and colour on silk with ivory jiku
Walters Art Museum, Baltimore, USA

Elegant court ladies and their maids relax on a spring
morning in the Han Dynasty Imperial Palace. Some chat
and eat, some play Chinese musical instruments and dance.
Qiu Ying was a versatile painter, admired for his skills in
ink wash, line and fine brush painting and his ability
to excel across a wide range of subjects: he was equally
adept at depicting figures, birds, flowers, buildings and
landscapes. This work can be categorised as 'belle painting',
as the traditional Chinese portrayal of beautiful women is
termed, and as 'ruler-lined painting', which is traditional
Chinese painting of architectural subjects. With its
panoramic view, the painting conveyed movement at a time
where there were no moving images. Depictions of court
ladies' activities were a traditional part of Chinese painting.
Placed decoratively around the architecture, the figures
are dressed in costumes that Qiu Ying closely modelled on
those worn during the Tang and Song Dynasties, though
the women's bodies are slimmer, reflecting the fashions of
the Ming Dynasty.

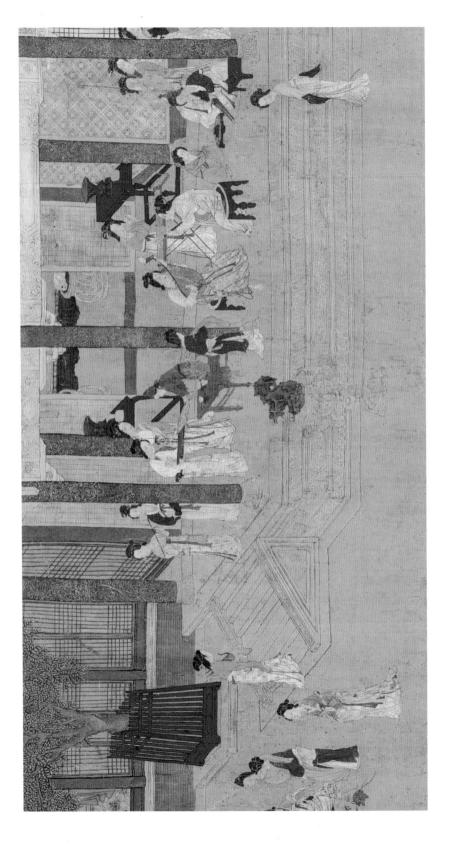

In the Picture

1 How many people can you see in this portion of the painting?

2 What activity do you think the women sitting on the floor around the short red-legged table are engaged in?

3 How many tables with red surfaces can you see?

Visual Matching

Can you find the following visual details in the painting?

4 5 6

General Knowledge

7 During which dynastic period did the artist Qiu Ying create this painting?

8 The painting depicts a spring morning in the Imperial Palace of the Han Dynasty – but during what years was the Han Dynasty in power?

9 The Emperor Yuandi had so many concubines that he had an artist paint all their portraits, so he could choose which ones he wanted to see each day. But do you know why Wang Zhaojun, one of the concubines, had a considerably less attractive image painted of her?

The greatest painter
of the Spanish School,
Diego Velázquez was painter
to and friend of King Philip IV
of Spain - and this is a royal
family portrait.

Often considered
one of the greatest ever painters,
Velázquez influenced many other
artists, including Édouard Manet,
John Singer Sargent, Pablo Picasso
and Salvador Dalí.

18

Las Meninas
Diego Velázquez (1599–1660)

1656

Oil on canvas

Museo Nacional del Prado, Madrid, Spain

The royal court are gathered in Velázquez's studio within
the palace. In the centre is the five-year-old Infanta
Margarita, the daughter of Philip IV of Spain and his second
wife, Mariana of Austria. Velázquez portrays her as a golden
child, with light shining on her hair and elaborate dress.
She is surrounded by her maids (*meninas*). One kneels
and offers her a drink on a golden tray. In a tiny mirror
on the wall, the king and queen are reflected. The queen's
chamberlain is on steps by an open door, and Velázquez
includes a full-length portrait of the artist at work: he is
standing behind his canvas, holding a brush and palette.
Many European monarchs had their 'own' dwarfs, and
Velázquez was friends with those at the Spanish court. The
two shown here are part of Philip IV's retinue: Maribárbola,
or Maria Bárbola; and Nicolás Pertusato or Nicolasito, the
Court Jester, who playfully tries to rouse the dozing dog
with his foot.

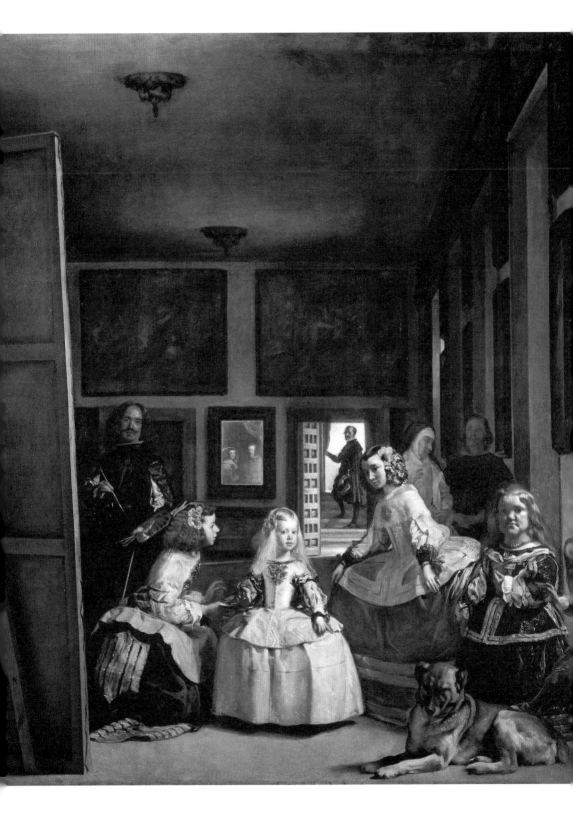

In the Picture

1 How many different human figures can you see in the image?

2 There are two sources of light in the painting. One is from the right hand side of the picture; where is the other?

3 Can you spot a butterfly in the picture?

General Knowledge

4 Who has Velázquez portrayed as the artist in the painting?

5 Who is the artist painting?

6 While the original painting is from 1656, the young girl's cheek was repainted in 1734 – why?

Visual Matching

Can you find these details in the picture?

7 **8** **9**

Vermeer was most
admired for his clever rendering
of light - as seen in this painting
where tiny white dots represent
the sparkle of reflected light.

Vermeer remained relatively
unknown outside of Delft until the
late nineteenth century. His reputation was
cemented in 1995 with a major exhibition at the
National Gallery of Art in Washington, D.C. The
publication of Tracy Chevalier's novel *Girl with a
Pearl Earring* followed in 1999, and this
was turned into an Oscar-nominated
film in 2003.

19

The Milkmaid
Johannes Vermeer (1632–75)

c.1660

Oil on canvas

The Rijksmuseum, Amsterdam, Netherlands

Wearing a yellow bodice with green sleeves, a blue apron
and a white headdress, a milkmaid stands next to a table,
intent on her task of pouring milk from a jug into a cooking
pot. The table is covered with a blue cloth, and light from
a window in front of the milkmaid falls on her forehead,
bodice and forearms, and onto parts of the table and the
flowing white milk – the only thing moving in the image.
On the table is a basket of bread and some rolls. Domestic
chores were a common feature in Dutch art, and this
composition radiates the quiet calm of a woman diligently
undertaking her daily tasks. A Delft tile at the lower right
depicts Cupid brandishing his bow, which implies that
the milkmaid is probably dreaming of love. Another Delft
tile features a picture of a man with a walking stick and
knapsack, possibly suggesting that she is thinking of an
absent lover.

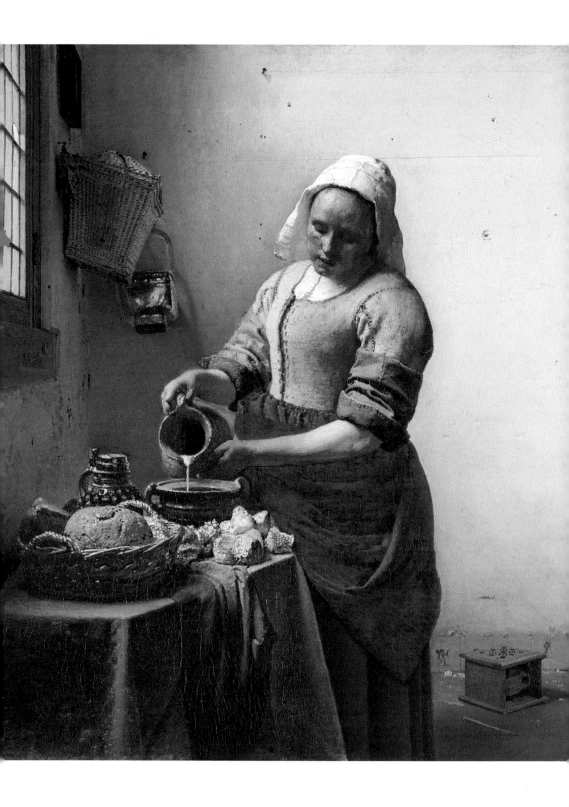

In the Picture

1 What is notable about the walls in this image?

2 What do you think the brown box on the floor, behind the milkmaid, might be?

3 Images of milkmaids and kitchen maids from this period were often flirty or suggestive. Can you find any visual hints that Vermeer may have intended to imply this idea within this painting?

General Knowledge

4 What is it thought that the milkmaid is making?

5 Vermeer originally painted something else instead of the brown box – what was it?

6 Instead of a 'milk' maid, what is the alternative title sometimes given to this painting?

Visual Matching

Can you find these details in the picture?

7 **8** **9**

Twenty-two years before he painted this, Goya had suddenly become permanently deaf as a result of an illness.

Between 1819 and 1823 Goya produces a series of fourteen works known as the 'Black Paintings'. They depict intense and haunting scenes, reflecting Goya's bleak outlook and fear of insanity.

20

The Third of May 1808
Francisco de Goya (1746–1828)

1814

Oil on canvas

Museo Nacional del Prado, Madrid, Spain

On 2 May 1808, Napoleonic troops marched into Madrid. Seeking to protect their city, many citizens rose up against them, but they were no match for the army. The following day, in retribution, French soldiers rounded up hundreds of Spanish civilians and shot them. Six years later, Francisco de Goya was commissioned to paint the event. A row of French soldiers aim their rifles at victims at point-blank range. Brilliantly lit by a lantern, one of the men, a labourer in a white shirt, kneels on the ground and flings out his arms. In the foreground, a dead man echoes this spread-armed pose, while dead bodies are piled up behind. Among the civilians, a figure praying is a Franciscan friar, who, despite being a member of a religious order, has been rounded up with the other victims, even though he would have been unlikely to have taken part in the previous day's insurrection.

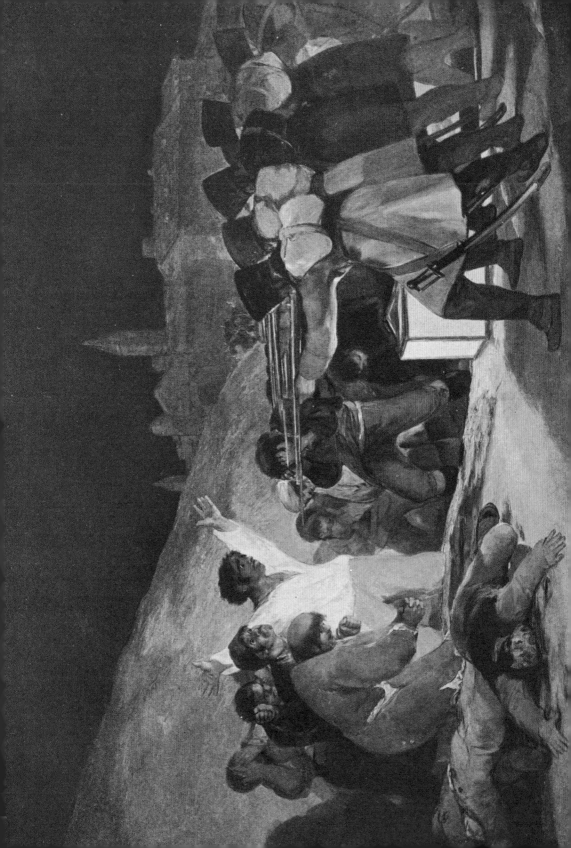

In the Picture

1 Why do you think the man in white and yellow has his arms spread open?

2 How many figures are covering their faces with their hands?

3 While we see the faces of the Spanish resistance fighters, what is notable about the French soldiers who are shooting them? Why do you think this is?

Visual Matching

Can you spot the following details in the picture?

4 5 6

General Knowledge

7 Which art historian called this painting 'the first great picture which can be called revolutionary in every sense of the word, in style, in subject, and in intention'?

8 The Spanish painter Goya was commissioned to paint both this image and a companion piece. What was the companion piece called?

9 Who was the driving force behind the invasion of Spain by the French in 1807?

The Edo period was
a time of more than 200 years
of unprecedented peace and
prosperity which saw a blossoming
of artistic, cultural and social
development.

During the Edo period
(c.1603–1868), ukiyo-e artists
became great innovators in
woodblock printing techniques,
which are still used by artists
around the world today.

21

Ryōgoku Bridge and the Great Riverbank
Utagawa (Andō) Hiroshige (1797–1858)

c.1856
Woodblock print on paper
Brooklyn Museum, New York, USA

Spanning the Sumida River, the Ryōgoku Bridge was built
in Edo (now Tokyo) in 1659. Almost two hundred years later,
Hiroshige created a woodblock print of it as part of his
series, *One Hundred Views of Edo*. He described Ryōgoku
Bridge as 'the liveliest place in the Eastern Capital, with
side-shows, theatres, story-tellers, and summer fireworks;
day and night, the amusements never cease.' This is his
stylised view of the bridge, seen from a high viewpoint,
with people bustling about on it and on land, and various
boats on the river. On the riverbank, people mingle wearing
traditional Japanese dress, some under parasols, as they
visit the various tea stalls. There is a constant flow on the
bridge as figures pass each other, crossing each way; and
on the river, both passenger and cargo boats can be seen.
In the distance on the opposite bank are even more figures,
and the whole scene is set beneath a fiery red sunset.

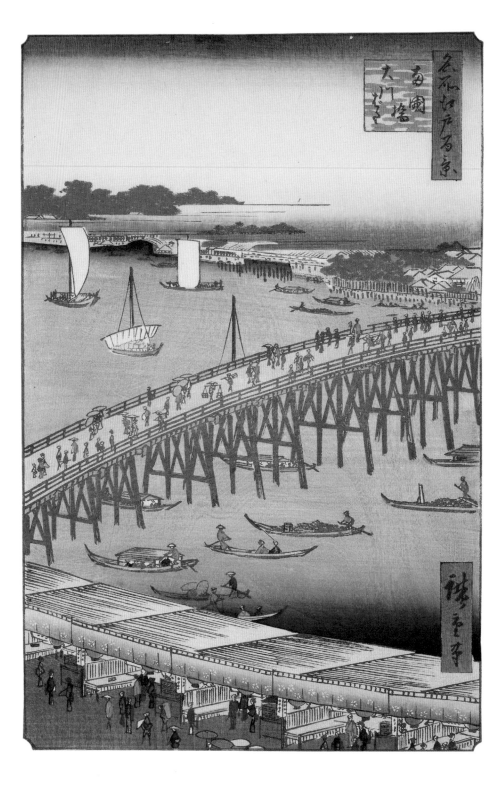

In the Picture

1 How many boats can you see on the river?

2 How many blue parasols can you count?

3 What letter could the composition be said to represent?

4 Can you find the breakwaters?

General Knowledge

5 Hiroshige travelled the length of the Tōkaidō road in 1832, from which he painted the Ryōgoku Bridge. Which cities did the Tōkaidō run between?

6 This image is part of a series of ukiyo-e woodblock prints, but what does ukiyo-e mean?

7 What do you think the area pictured at the bottom of the image was used for?

8 When did Kyōto cease to be the capital of Japan, and why?

9 On which Japanese island is the scene located?

Monet's fragmented touches of colour illustrate his mastery at conveying optical effects and revealing the ways that our eyes actually see things.

In Monet's later life he developed cataracts and his eyesight weakened. Some of the paintings he created during this time have an unusual reddish tone: this is characteristic of the vision of people with cataracts.

22

The Artist's Garden at Vétheuil
Claude Monet (1840–1926)

1881

Oil on canvas

The National Gallery of Art, Washington, D.C., USA

In September 1878, Monet rented a large house in Vétheuil, a quiet village on the banks of the River Seine. The house had terraces leading down to the river and Monet arranged with the owner to landscape them. Concentrating on the brilliant summer light and the vivid colours of the flowers, here he has captured a direct view of the terraced path leading from the house down to the river. On the path in front of the tall sunflowers, a small boy is pulling a toy wagon. Behind him are members of the artist's extended family who also lived in the house. No faces are clearly defined; everything blurs in the bright sunlight and dappled shade. Only a small portion of sky and tantalising glimpses of the house are visible, as Monet concentrated on capturing a spontaneous, momentary effect. He owned the large blue and white flowerpots, and also painted them in other locations when he moved house.

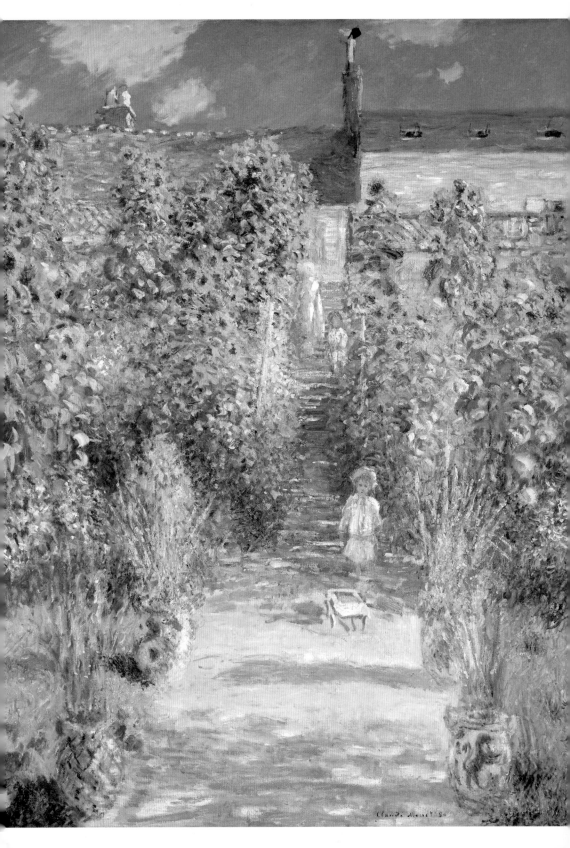

In the Picture

1 How many figures can you count in this painting?

2 What colours does Monet use to paint the sunflowers themselves?

3 What visual elements does Monet combine to give the garden a sense of depth and perspective?

Visual Matching

Can you spot the following details in the picture?

4 **5** **6**

General Knowledge

7 What type of flowers are pictured in the blue and white flowerpots?

8 Monet made another painting of the garden at Vétheuil, and he loved to paint the same scene at different times of the day and year. Can you think of other examples of objects and places he painted several times in this way?

9 Who is the child in the foreground?

The red triangle on
the brown bottles to the left and
right is the Bass Brewery logo. The British
company was established in 1777, and in
1876 its logo became the UK's first
registered trademark.

23

A Bar at the Folies-Bergère
Édouard Manet (1832–83)

1882

Oil on canvas

The Courtauld Gallery, London, UK

Established in 1869, the Folies-Bergère was a music hall where rich Parisians were entertained with ballet, cabaret, acrobatics, pantomime and operetta. This is a view of its horseshoe-shaped interior: it was supported by columns, with a balcony running around it, and a promenade with several bars. Standing in front of a vast mirror, a young woman (Suzon) is serving at one of those bars. We see her in actuality, facing us, with her back view reflected in the mirror behind, leaning towards a tall customer in a top hat. The figure of Suzon is the only person in the painting who is not a reflection. Manet intentionally made all the angles illogical. For instance, although Suzon is standing directly in front of viewers, the man she is speaking to is seen at an angle. In the background, a crush of visitors and entertainers can be seen, while on the marble-topped bar are bottles, oranges and flowers in a glass vase; a still life amid the busy throng.

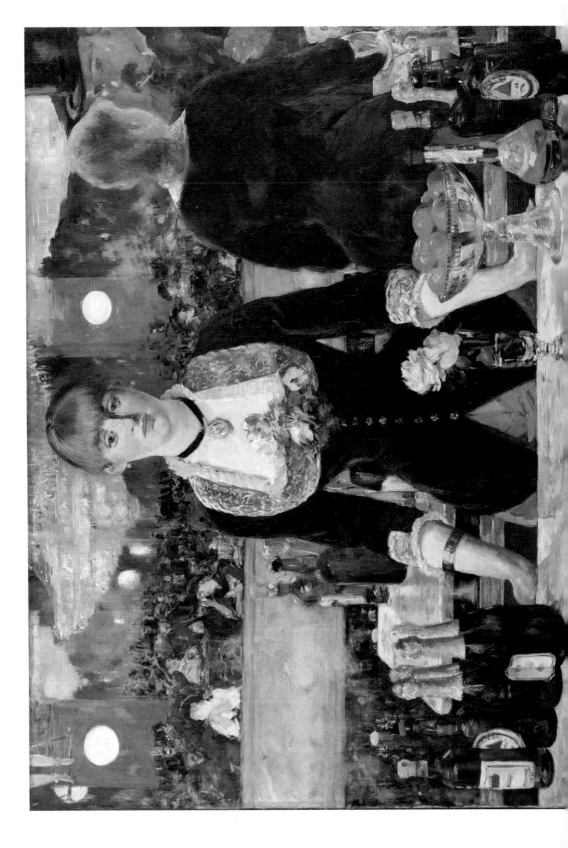

In the Picture

1 How many gold-wrapped champagne bottles sit on the bar?

2 Who is the woman pictured on the right-hand side of the image, talking to the man in the top hat?

3 Can you find a trapeze artist?

General Knowledge

4 Why is this considered a particularly notable painting by Édouard Manet, in terms of all of the paintings he created?

5 Which composer, who was a close friend of Manet's, owned this painting?

6 What element in the painting is thought to represent anti-German sentiment following the Franco-Prussian War of 1870–71?

Visual Matching

See if you can find the following details in the painting:

7

8

9

This monumental painting, with its painstaking technique, took Georges Seurat two years to complete.

Seurat's painting inspired a number of parodies, being prominently featured in the film *Ferris Bueller's Day Off*, as well as in the TV series *Family Guy*, *The Simpsons* and *The Office*.

24

A Sunday on La Grande Jatte
Georges-Pierre Seurat (1859–91)

1884–86

Oil on canvas

The Art Institute of Chicago, Illinois, USA

La Grande Jatte is an island on the River Seine where rich and fashionable Parisians came to enjoy themselves on summer Sunday afternoons in the late nineteenth century. Georges Seurat painted a serene view of it using a new technique that he called divisionism, but which has become known as pointillism. With no outlines, the painting is made up of tiny dots of pure colour, which, when placed adjacently, blend optically in viewers' eyes rather than through physical mixtures of paint. Within the scene, people are relaxing – they include a couple with a monkey and a little dog, a nanny holding a little girl's hand, another little girl chasing a butterfly, a man playing a horn, and a woman fishing. A man reclines with a pipe, a dog sniffs around the remains of a picnic, another man holds a cane while watching the boats, and a woman knits. Vibrant and vast, the composition is carefully planned, with figures, trees, light and shadows creating a fascinating pattern.

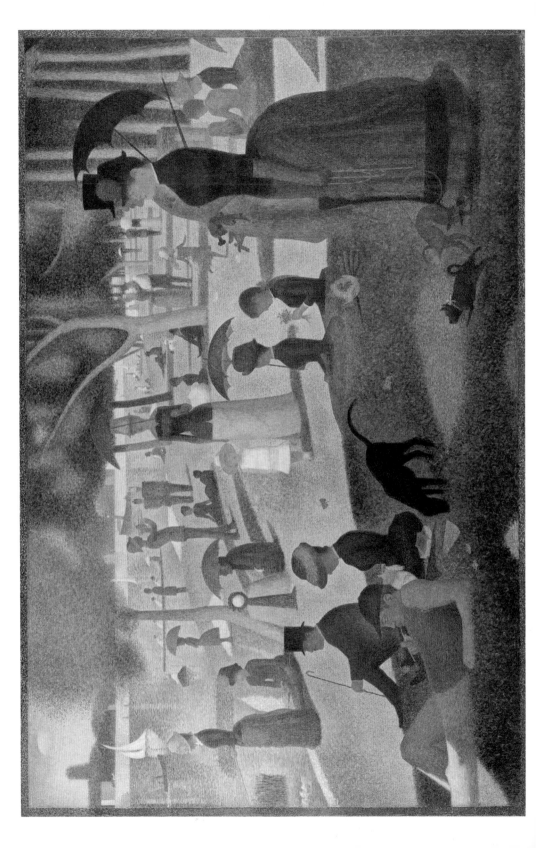

In the Picture

1 Can you find the monkey in the image?

2 How many parasols can you count?

3 How many types of boat are on the water?

General Knowledge

4 What painting technique is Seurat using here?

5 This painting famously heralded the start of a new art movement. What was it?

6 In the US, there is a topiary park cut to replicate much of this painting. Where is it?

7 There are a couple of 'unusual' women in the painting. One appears to be fishing, the other has a monkey on a leash. Who do historians suspect these women might be?

Visual Matching

Can you find the following details in the painting?

8 **9**

Vincent van Gogh painted this before dawn from his room in the asylum at Saint-Rémy where he was recovering after cutting off his own ear.

When Van Gogh's younger brother, Theo, died in 1891, his widow was left with hundreds of paintings, letters and drawings. Johanna became the driving force of Van Gogh's posthumous success: donating his works to retrospective exhibitions and editing the brothers' correspondence for publication.

25

The Starry Night
Vincent van Gogh (1853–90)
1889

Oil on canvas

The Museum of Modern Art, New York, USA

'This morning I saw the countryside from my window a long time before sunrise, with nothing but the morning star, which looked very big,' wrote Vincent van Gogh to his brother Theo about this painting. His window was in an asylum in southern France, where he was staying in the hope of recovery from psychiatric disorders. Dominated by thick, swirling brushmarks and mainly blues and yellows, the scene is a mixture of Vincent's observations and his imagination. With radiating brushstrokes, the bright orbs and crescent moon seem to vibrate in the dark sky. To the left, a huge silhouetted cypress tree possibly symbolises Vincent's feelings of isolation from the rest of society, while in the shadow of distant mountains, a village with a church spire seems to connect the earth and the heavens. The painting may have been influenced by a Biblical story in the Book of Genesis (37:9), in which Joseph tells his brothers of a dream in which 'the sun and the moon and the eleven stars made obeisance to me'.

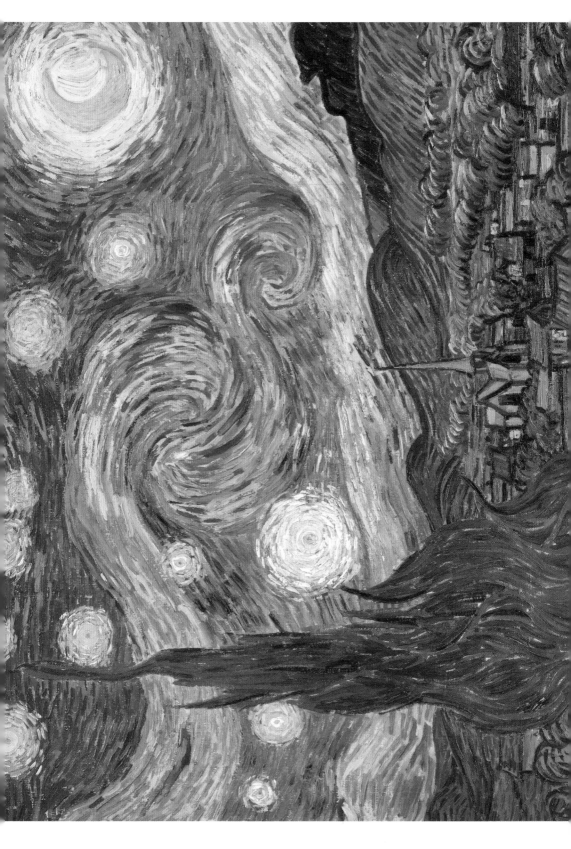

In the Picture

1 How many celestial bodies can you count in the sky?

2 How many lit windows can you count in the town?

3 Which of the celestial bodies represents Venus?

General Knowledge

4 Where was Van Gogh when he painted this picture?

5 The green trees in the foreground of the painting are cypress trees. What do cypress trees usually represent in European culture?

6 How did Van Gogh die?

7 Whose body is buried alongside Vincent van Gogh's at the cemetery of Auvers-sur-Oise?

Visual Matching

Can you find the following details in the painting?

8 **9**

In 1894 Valadon was the first woman to be admitted to the Société Nationale des Beaux-Arts.

Valadon's son was also an artist. She completed many of his paintings when he was unable to because of his alcoholism.

26

Portrait of Marie and Gilberte
Suzanne Valadon (1865–1938)

1913
Oil on canvas
Musée des Beaux-Arts, Lyon, France

The picture shows Suzanne Valadon's niece, Marie Coca, and her daughter Gilberte. Using dark outlines and bold colours, Valadon composed the figures so that they seem to project forward. Working in a particularly male environment, she became friends with Degas, Toulouse-Lautrec, Renoir, Puvis de Chavannes and other male artists who gave her advice about painting. The simplified shapes and angled composition evolved from the work of Degas and Toulouse-Lautrec, while the strong outlines appear to have been inspired by Cloisonnism (the Post-Impressionist style associated with Paul Gauguin), although Valadon denied being influenced by other artists. Much of the image is created with curving, irregular and diagonal lines in deep blue and umber, and it is clear that Valadon was as concerned about rhythm and pattern as about representing reality.

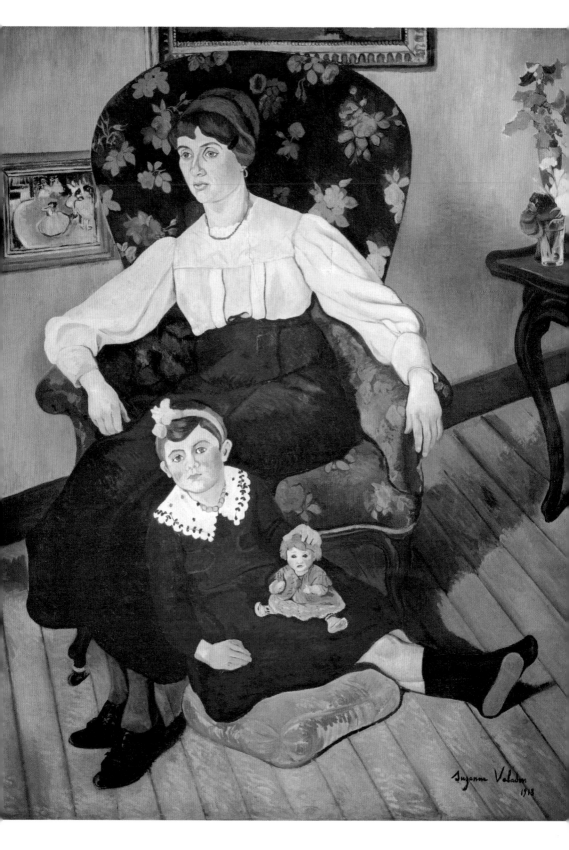

In the Picture

1 The picture displayed on the wall beside the armchair is a reproduction of a painting by which artist?

2 What types of plant can you see on the table?

3 How many pieces of jewellery can you identify in this painting?

Visual Matching

Can you find the following details in the painting?

4 **5**

General Knowledge

6 In 1894, Valadon became the first female painter to be admitted to what society?

7 How many times was Valadon married?

8 Name a famous painting featuring Valadon by Renoir.

9 Valadon's son became a well-known painter specialising in cityscapes. What was his name?

In 1965 the French fashion designer Yves Saint Laurent designed six cocktail dresses that he called the Mondrian Collection. Each dress was based on Mondrian's paintings.

27

Composition with Large Red Plane, Yellow, Black, Grey and Blue
Piet Mondrian (1872–1944)

1921

Oil on canvas

Gemeentemuseum Den Haag, The Hague, The Netherlands

Piet Mondrian was originally known for painting landscapes until he developed an interest in the mystical principles of Theosophy. This esoteric religious movement dramatically changed his approach, and, in turn, made his work overwhelmingly influential on twentieth-century art and design. As part of De Stijl ('The Style') – a Dutch art movement that advocated the use of only essential form and colour – and what Mondrian described as Neo-Plasticism, he began to simplify his paintings to create completely abstract art. Based on his philosophical beliefs about Theosophy and the spiritual order of the world, he explored new artistic theories. By reducing the elements of his paintings to their most fundamental and purest forms – using only primary colours, black and white, and horizontal and vertical lines – he was seeking to create harmony and reveal the essence of nature and its mystical energy. For *Composition with Large Red Plane, Yellow, Black, Grey and Blue* he painted the canvas white, then created an asymmetrical grid of vertical and horizontal black lines. Finally, he painted the three primary colours of red, yellow and blue in flat slabs.

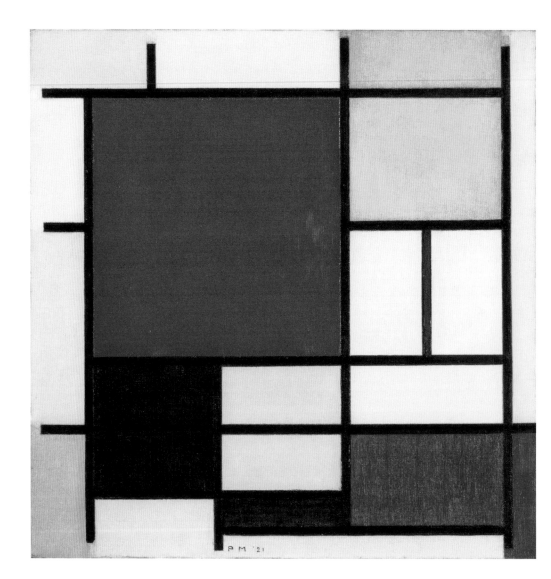

In the Picture

1 How many complete boxes can you count in the image?

2 Which colour covers the largest surface area?

3 What is the lowest possible number of continuous straight lines that could be used to draw this image?

General Knowledge

4 Which art movement and group did Mondrian co-found, along with Theo van Doesburg?

5 Post-Impressionism was an early influence on Mondrian, but what style of art did he next start experimenting with before he founded his new art movement?

6 Which city did Mondrian move to from 1938–40?

Visual Matching

7 Which of the following sets of lines exactly matches those in the original painting? The images have all been differently rotated and/or flipped in order to make it trickier to compare them.

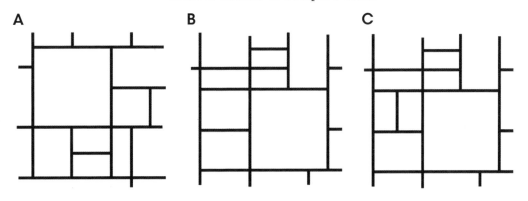

A B C

When Spanish Joan Miró moved to Paris, he was so poor and hungry that he later claimed he hallucinated, a condition which inspired his 'automatism', or unconscious painting.

28

The Tilled Field
Joan Miró (1893–1983)

1923–24

Oil on canvas

Solomon R. Guggenheim Museum,
New York, USA

This represents Joan Miró's family farm in Mont-roig
del Camp, Catalonia, depicted with objects from his
imagination. Overall, yellow signifies sunlight, representing
hope. Miró's style played a key role in the development
of Surrealism and also in graphic design. His range
of influences included medieval Spanish tapestries,
Romanesque Catalan frescoes and *The Garden of Earthly
Delights* by Hieronymus Bosch (see pages 32–35). Eyes
appearing in various places recall early Christian art, where
angels were often embellished with tiny eyes in response
to the verse in the Biblical Book of Ezekiel (10:12): 'And
their whole body, and their backs, and their hands, and
their wings, and the wheels, were full of eyes.' Ears convey
Miró's belief that every object contains a living soul, and the
stylised figure with a cattle-drawn plough is based on the
prehistoric cave paintings of Altamira in Spain, with which
he was familiar. A Spanish lizard wearing a hat and carrying
a folded Parisian newspaper symbolises both where he was
born and where he was currently living.

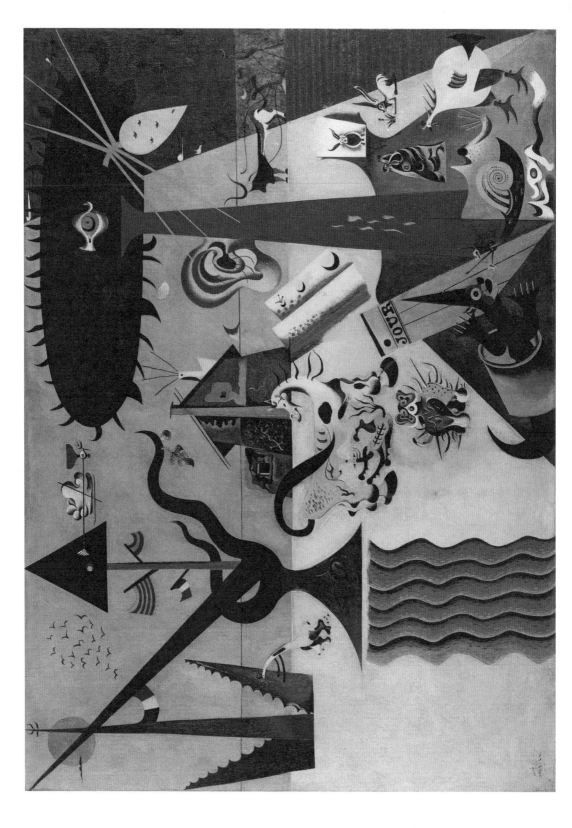

In the Picture

1 Which three different national flags hang from the border post to the left of the centre? To what do you think they refer?

2 What art movement does this painting belong to?

3 What animals can you see in this painting?

4 What might the vertical wavy lines on the left and the horizontal lines on the far right represent?

5 Can you find a 'day' in the image?

General Knowledge

6 The picture is divided into three sections by two horizontal lines. What are each of the three areas said to represent?

7 In which Spanish region did Miró grow up?

8 Why did Miró place eyes and an ear on the tree?

9 Miró used muted colours in this image. Why did he do this?

In 1911 the *Mona Lisa* was famously stolen from the Louvre in Paris, and Picasso and his entourage were accused of the heist. When the police searched Picasso's apartment, they found no sign of Leonardo da Vinci's masterpiece.

One of Picasso's many anecdotes told of an encounter with a Gestapo officer who had barged into his apartment. The officer pointed at a photo of *Guernica* and asked, 'Did you do that?' To which Picasso replied, 'No, you did.'

29

Guernica
Pablo Picasso (1881–1973)

1937

Oil on canvas

Museo Nacional Centro de Arte Reina Sofía, Madrid, Spain

The black, grey and white of this huge painting echoes the look of the newspaper from which Picasso learned of the massacre. During the Spanish Civil War (1936–39), German and Italian planes supporting the Fascist forces of General Franco bombed the Basque town of Guernica. It is estimated that between 200 and 250 innocent civilians were killed, and many hundreds wounded. Picasso's distortions convey the horror and suffering incurred. On the left, a woman holding her dead baby throws back her head and howls. Nearby, symbolising Spain and also the ruthless Fascist regime, a bull swishes its flame-like tail. In the centre, a dying horse (symbolising the people of Guernica) rears over a soldier whose severed arm still grasps a broken sword. Across the scene, a woman lunges in despair, another screams from a burning building, and another leans out of a window, holding a candle. Above all, a light bulb blazes, looking jagged and explosive.

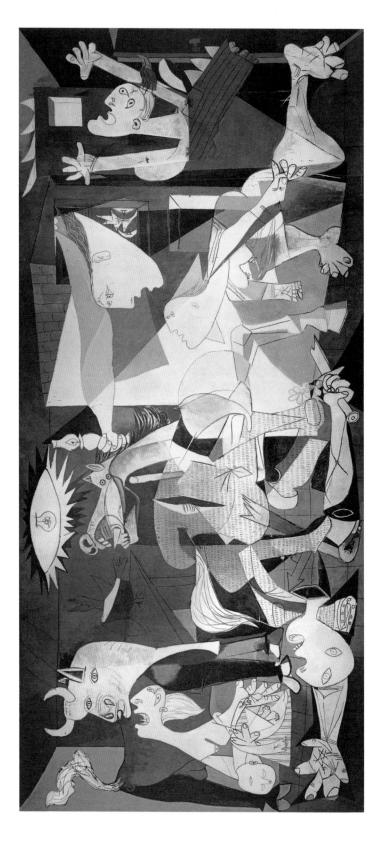

In the Picture

1 Can you find a symbol of Christ's martyrdom on someone's body?

2 What faintly drawn item has been drawn above a broken sword? What might it symbolise?

3 How many different animals can you identify in the painting?

General Knowledge

4 Why was the picture painted in black, white and grey?

5 Why is this considered Picasso's most political painting?

6 Jacqueline de la Baume Dürrbach made a full-size copy of this painting in what medium? Why did she do so?

7 Where is the town of Guernica located?

8 In which city did Picasso paint Guernica? (It was the city he lived in for most of his life.)

9 How many words are there in Picasso's full name?

'At the age of six
I wanted to be a cook. At
seven I wanted to be Napoleon.
And my ambition has been
growing steadily ever since.'
Salvador Dalí

In 1936 the seminal International
Exhibition of Surrealism opened in
London. To mark the occasion, Dalí wore a full
diving suit, held two dogs on leads and carried
a billiard cue. However, the eccentric outfit didn't
quite go to plan and Dalí began to suffocate under
the weight of the helmet, which had to be
prised open with the billiard cue. The
show put Surrealism on the map.

30

Metamorphosis of Narcissus
Salvador Dalí (1904–89)

1937
Oil on canvas
Tate Modern, London, UK

In Greek mythology, Narcissus was a beautiful youth, the son of a god and a nymph, who loved only himself and broke many hearts. So the gods punished him. One day, he glimpsed his own reflection in a pool and fell in love with it. For months he waited by the water, longing for the beautiful individual to emerge ... but, of course, he never did, and eventually Narcissus died. Feeling sorry, the gods immortalised him as a flower. Here, Narcissus sits in a pool, his head on his knee, gazing into the water. Next to him are some balancing stones that echo his pose; they also resemble a hand holding an egg from which a narcissus (daffodil) is growing. This is the metamorphosis of the youth into the flower. Dalí often used eggs as symbols of sexuality, and ants (seen on the stone hand) to represent death and decay. Further back in this scene is an image depicting an earlier time, where Narcissus stands alone on a plinth, distanced from the other figures.

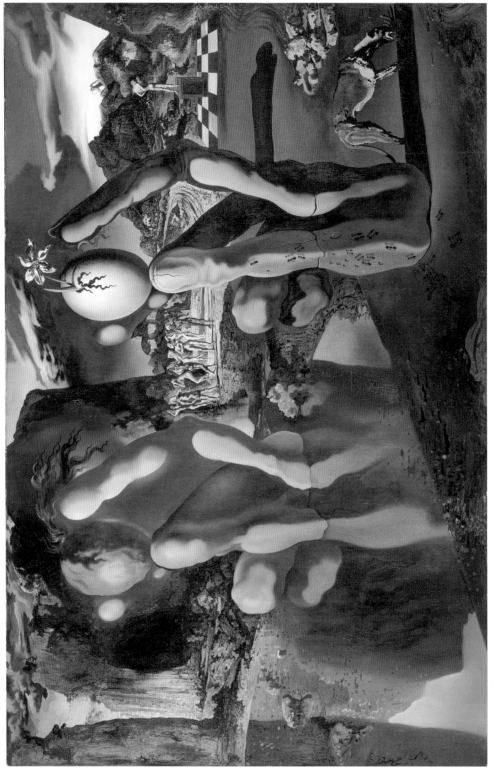

In the Picture

1 Part of what game board can be seen in the image?

2 What images of sexuality are used in the painting?

3 What insects can be seen in this painting?

4 Dalí was fascinated by delusion and hallucination. What notable feature of the painting mimics the pose of Narcissus?

General Knowledge

5 According to Greek mythology, why does Narcissus sit staring into the water?

6 What other art form accompanied the painting when it was first exhibited?

7 Dalí took this painting with him when he met which famed psychoanalyst in 1938?

8 Dalí called his realistic style 'hand-painted dream photographs', suggesting truth or realism. He also referred to his methods by what other two-word term, that referenced the surreal combination of images, many of which are strangely disconcerting, making you question whether what you are seeing is real or not?

9 Renowned for his flamboyant personality as much as for his technical ability, Dalí loved to shock. For instance, in the 1960s he had a pet that went everywhere with him. What was it?

As well as working in fine art and crafts, Sonia Delaunay also collaborated with poets. She said: 'Painting is a form of poetry, colours are words, their relations rhythms, the completed painting a completed poem.'

Sonia and her husband Robert Delaunay created a form of Cubism that they called Simultanism. Their friend, the writer and critic Guillaume Apollinaire (1880–1918), called it Orphism after the mythological musician and poet Orpheus, and that name stuck.

31

Rythme 38
Sonia Delaunay (1885–1979)
1938
Oil on canvas
Musée National d'Art Moderne, Centre
Georges Pompidou, Paris, France

After growing up in Ukraine and St Petersburg, Sonia Delaunay studied painting in Germany, and moved to Paris when she was 23. There she became inspired by Post-Impressionism, Cubism and Fauvism, as well as the colour theories of the French chemist Michel-Eugène Chevreul. She also explored light, metaphysics and expressed her childhood memories of Ukraine and Russia. Fascinated, from the 1930s, by the idea that painting could resemble music – in having rhythms, nuances, highs and lows, and not necessarily representing the visual world – she created *Rythme 38* for the 15th annual Salon des Tuileries in Paris in 1938 to represent modern art in France. Featuring bright colours and black and white, the large-scale painting comprises numerous adjacent semi-circles forming a line of disjointed circles along a central axis. Delaunay said that she explored colour 'to discover harmonies and dissonances that give colours a life of their own, investing them with a pulse and vibrations which, when later put in order, become rhythms.'

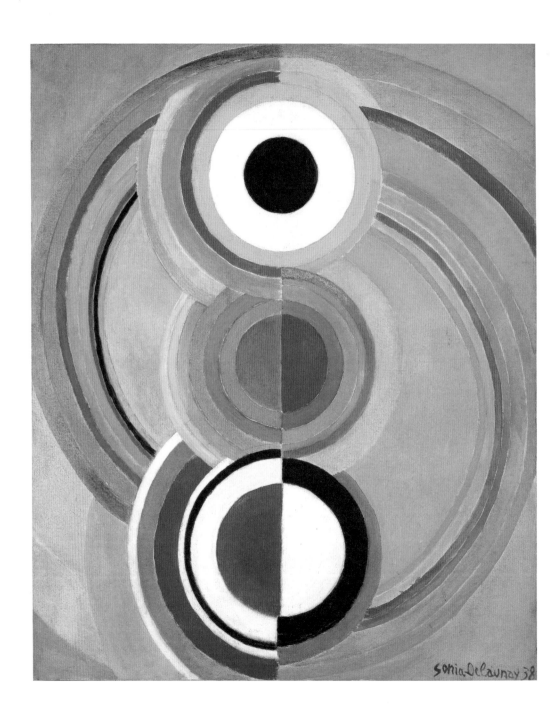

In the Picture

1 How many separate black areas can you count?

2 The image mostly consists of overlapping semicircles, but how many complete circles can you find?

3 How many red segments are there?

General Knowledge

4 What are complementary colours, and can you see any placed together within the picture?

5 The folk art of which country is an influence in the painting?

6 Which offshoot of Cubism did Sonia Delaunay co-found?

7 Delaunay's *Coccinelle* was featured on an object in both France and the UK to celebrate the centenary of the Entente Cordiale. What was the object?

8 What was Delaunay's birth name?

9 What was special about Delaunay's retrospective exhibition which opened at the Louvre in 1964?

Although several commentators described her as a Surrealist, Kahlo said: 'They thought I was a Surrealist, but I wasn't. I never painted dreams. I painted my own reality.'

Frida Kahlo had a fleeting affair with the Russian revolutionary Leon Trotsky. When Trotsky was assassinated in 1940, Kahlo was briefly suspected and was held for questioning.

32

Self-Portrait with Thorn Necklace and Hummingbird
Frida Kahlo (1907–54)

1940

Oil on canvas

Harry Ransom Center, University of Texas, Austin, USA

At the age of six, Frida Kahlo contracted polio. She was bedridden for nine months, and afterwards walked with a limp. At eighteen, she had a near-fatal accident when a tram crashed into her school bus. She never fully recovered, was in constant pain, and underwent approximately thirty-five operations during her life. In 1929, she married Diego Rivera, a famous Mexican painter, and from that time she dressed in traditional Mexican Tehuana costume. Rivera had a violent temper and was unfaithful, and Kahlo's paintings focus on her physical and mental pain, as well as her mixed heritage. This painting symbolises her feelings as she divorced Rivera. (They later remarried.) With many layers of connotation and symbols, Kahlo presents her own portrait, surrounded by animals she loved, conveying a sense of being trapped in her own life of suffering. Even the creatures she cared for combine both positivity and negativity. Some of the elements of the work recall Biblical themes, Aztec and Mexican folkloric beliefs, and her own powerful emotions. Beneath her exaggerated eyebrows, Kahlo stares, while butterflies in her hair represent both Christ's Resurrection and her escape from her marriage.

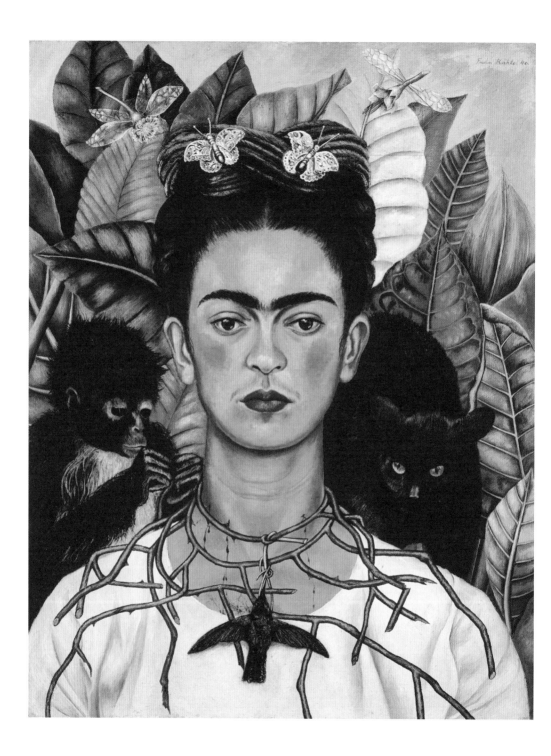

In the Picture

1 How many different creatures appear in the painting?

2 What do the thorns around Kahlo's neck bring to mind?

3 What does the black cat symbolise?

4 How is Kahlo balancing her luck?

General Knowledge

5 The black monkey was a gift from Kahlo's husband. Who was he?

6 Hummingbird pendants are a symbol of which god?

7 In which Disney Pixar film do we meet Frida Kahlo?

8 Kahlo was the first 20th century Mexican artist to be featured in which famous gallery?

9 What accident caused Frida Kahlo health problems throughout her life? And what separate condition led to her death?

Maurits Cornelis Escher was 70 before a retrospective exhibition was held of his work.

Escher visited the palace of the Alhambra in Granada, Spain in 1936. The geometric fractal patterns typical of Moorish art that he saw there inspired him to forego landscapes and experiment instead with interlacing patterns.

33

Relativity
M.C. Escher (1898–1972)

1953

Lithograph

Museum of Modern Art, New York, USA

Defying the laws of gravity, this architectural structure, with its illusion of depth and solidity, features stairs, windows, doors, arches and balconies. Aiming to confuse the boundaries between flat images and three-dimensional planes, M.C. Escher used three-point perspective to create it, with three vanishing points that form an equilateral triangle, and each side of the triangle acting as a horizon. If you tilt the image, each plane 'makes sense'. Going about their daily lives, figures in identical clothing with featureless bulb-shaped heads pass each other at different angles. Most are oblivious to anyone else. One carries a sack, another a tray, two eat, another sits on a bench. Two are on the same stairway, each climbing a different face of the same step. Escher explained: 'On the top staircase ... two people are moving side by side and in the same direction, and yet one of them is going downstairs and the other upstairs. Contact between them is out of the question because they live in different worlds and therefore can have no knowledge of each other's existence.'

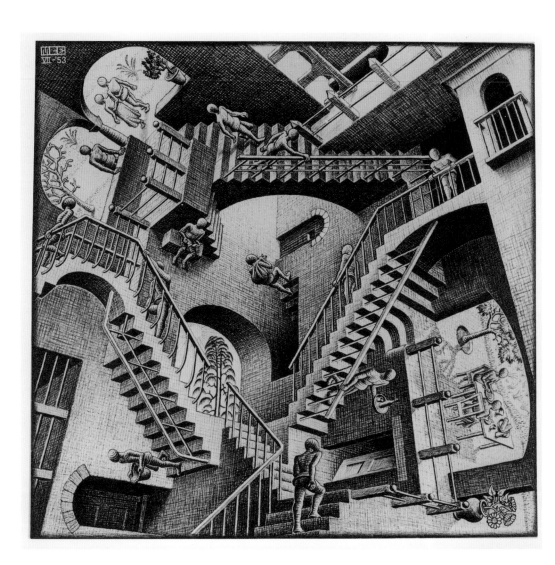

In the Picture

1 How many figures can you count in the image?

2 How many staircases that can be used in more than one plane can you count?

3 How many archways provide the image with light?

4 Name all the things that the figures are holding.

5 How many gravity sources do there appear to be?

6 Can you find inhabitants from two different gravity sources on the same staircase?

General Knowledge

7 This image is a lithograph print, made in December 1953. How was the first version of *Relativity* created?

8 Which comedy film sees characters played by Ben Stiller, Dan Stevens and Robin Williams enter the artwork *Relativity*?

9 In 2003, Andrew Lipson and Daniel Shiu created a version of *Relativity* using which children's toy?

Rauschenberg's use of unconventional art materials arose from his childhood, when his mother made the family's clothes from scraps.

Some have suggested that Rauschenberg's new form of frantic expressionism was a direct rebellion against his teacher, the artist Josef Albers, who was known for his geometric forms and uniform colours.

34

Skyway
Robert Rauschenberg (1925–2008)
1964
Oil and silkscreen on canvas
Dallas Museum of Art, Texas, USA

Part of a series of silkscreened collages that Rauschenberg
made between 1963 and 1964, this was commissioned by the
architect Philip Johnson, and appeared on the façade of the
United States Pavilion (designed by Johnson) at the 1964
World's Fair in New York. It includes photographic images
from contemporary magazines and advertisements, and
silkscreened reproductions of *Venus in Front of the Mirror*
(1614–15) by Peter Paul Rubens. President John F. Kennedy
had been assassinated a year before *Skyway*'s creation,
and his image appears twice; as a martyr and a religious
icon. Overall, the work conveys contemporary America:
astronauts and planets represent US involvement in space
exploration; a construction site with a crane signifies
progress; and the bald eagle is the American emblem.
Three years apart in age, Rauschenberg and Andy Warhol
were producing art concurrently. Both sought to express
developments in American culture and both influenced one
another. Rauschenberg first saw the use of the silkscreen
process in fine art at Warhol's studio in 1962.

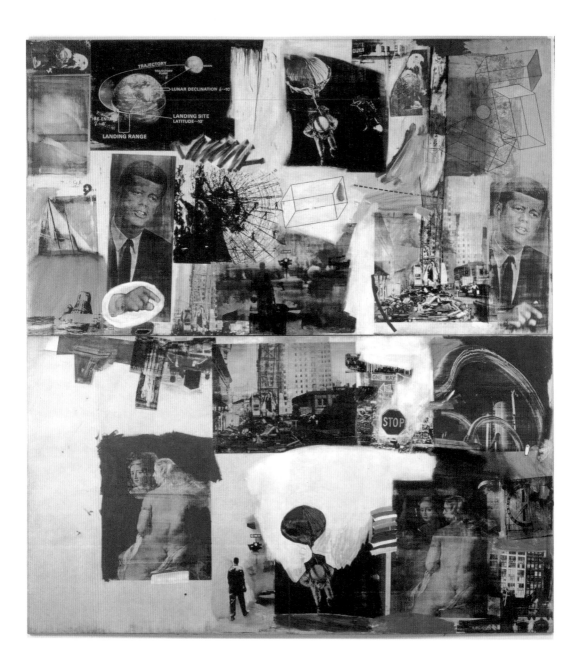

In the Picture

1. Who is pictured four times?

2. What type of bird can you spot in the collage?

3. What does the black-and-white image featuring the moon show?

4. What do you think Rauschenberg was intending the viewer to feel by using many different images within this one painting?

5. How many street signs can you count?

General Knowledge

6. What are the names of the art movements that exploited images from the mass media?

7. Which artist introduced Rauschenberg to the photo-silkscreen technique?

8. What style of art did works like *Skyway* consciously reject?

9. Which event did a well-known US government agency invite Rauschenberg to witness in 1969?

In 2017 Basquiat's
Untitled (1982) sold for
$110.5 million at auction, making
it the most expensive piece of
artwork by an American
artist at the time.

'I'm not a real
person. I'm a legend.'
Jean-Michel Basquiat

35

Furious Man
Jean-Michel Basquiat (1960–88)
1982
Oilstick, acrylic, wax crayon and ink on paper
Private collection

Basquiat's mother gave him a copy of the book *Gray's Anatomy* while he was recuperating from a childhood operation. Fascinated, he began drawing sinewy, anatomical figures, and later he painted them, adding elements from graphic novels and cartoons. In the late 1970s, he was homeless, painting graffiti on the streets of Manhattan, but by the 1980s he was famous, and his paintings were exhibited internationally. His expressionistic approach mixed his early influences with aspects of hip-hop, punk and street art, as well as elements from his Puerto Rican and Haitian heritage, and African culture. Deliberately ambiguous, this painting suggests both spiritual and physical ideas and beliefs. With arms thrown up in surrender, alarm or aggression, the figure evokes medical X-rays, yet it also has bloodshot eyes, red spikes protrude from its head, and a golden halo hovers over it. In some ways, it expresses Basquiat's criticism of the stereotyping of black identity and his mocking of traditional Western painting. Against a background of scattered lines, stars and shapes, his gaunt and distorted figure projects his personal fears, anxieties and anger.

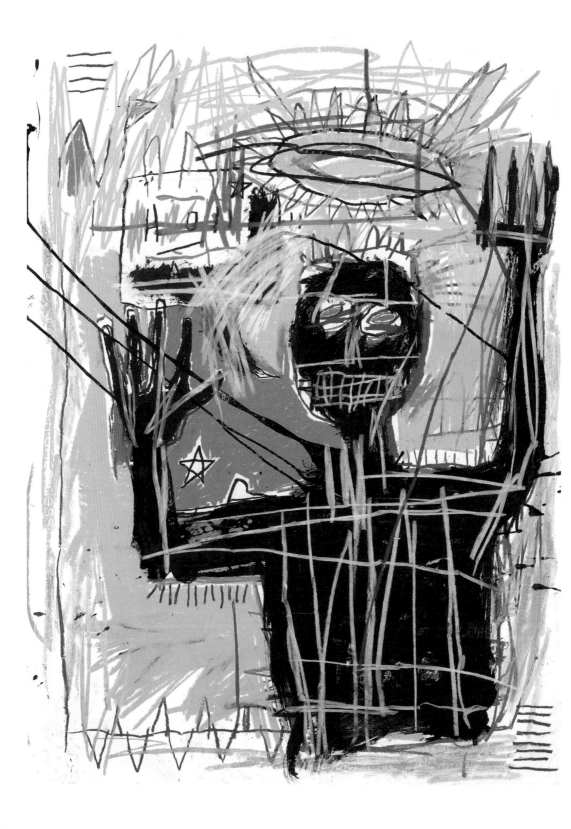

In the Picture

1 How many five-pointed stars can you count in the image?

2 What Biblical connotations are there within the image?

3 How many different colours of spike protrude from the black border of the halo?

General Knowledge

4 Under what name did Basquiat first come to fame as an artist?

5 In February 1985, on which notable newspaper magazine cover did Basquiat appear?

6 Who particularly encouraged Basquiat's interest in art while he was still a child?

7 Which film, released in 2000, starred Basquiat?

8 What unusual outfit combination was Basquiat often pictured wearing?

9 Basquiat died at the tragically young age of 27. Which artist created the 1988 work, *A Pile of Crowns for Jean-Michel Basquiat*, in his memory?

In 1986 Keith Haring
opened Pop Shop in Manhattan,
which sold his artwork in the form of
T-shirts, buttons, and other merchandise.
This made his art affordable
and accessible to all.

The biggest commercially
available jigsaw puzzle in the world
features Haring's paintings: 32 of them,
in fact. The puzzle consists of 32,000
pieces covering an area of
544 x 192 cm (214 x 76 in).

36

Tree of Life
Keith Haring (1958–90)
1985
Acrylic on canvas
Private collection

This dynamic, monumental painting celebrates life and friendship. The Tree of Life – a myth common to various early cultures – was generally believed to connect heaven and earth and all forms of creation. This work, produced at the peak of Keith Haring's short career, blends jarring elements of punk and street culture with the simplicity and exuberance of Pop art. The Tree is literally full of life. Green figures grow in place of leaves. Rhythmical lines depict them dancing and swaying on the branches, while four large spotted yellow figures standing beneath them appear to be worshipping the Tree. Using fluid, flowing paint and bright colours, Haring creates immediacy, aiming to connect with viewers on both conscious and unconscious levels. For him, the painting process was as important as the results. He said, 'When I paint, it is an experience that, at its best, is transcending reality ... you completely go into another place, you're tapping into things that are totally universal, of the total consciousness, completely beyond your ego and your own self.' Sadly, Haring died in 1990 of AIDS. He was just 31 years old.

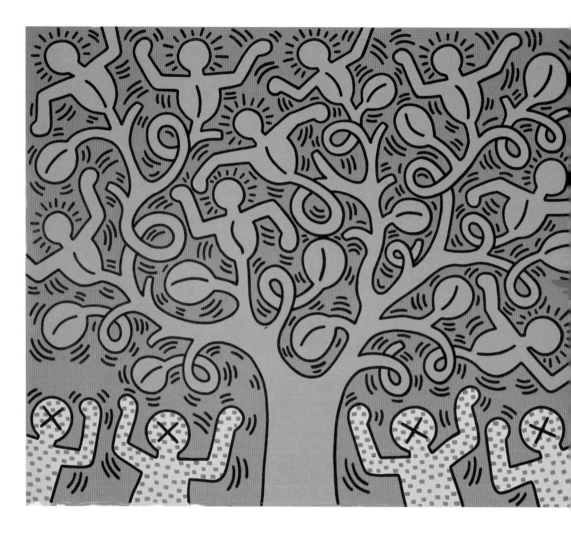

In the Picture

1 How many people-shaped leaves can you count?

2 How many different colours does the image use?

3 For what reason has Haring used the sets of two or three black lines around the various forms in the image?

General Knowledge

4 Haring was vocal in addressing political and social themes – in particular homosexuality and AIDS. Why do you think he created multiple figures sprouting from the Tree?

5 Why are some of the figures marked with a cross?

6 Which international figure held a benefit concert in Haring's memory in 1990, and donated all the proceeds from the ticket sales to AIDS charities?

7 Which renowned model, who Haring later physically painted, was introduced to the artist by Andy Warhol?

8 What French fashion brand began using Haring's designs in a range of fashion clothing in 2019?

9 Which world-famous landmark did Haring paint a section of in 1986?

ANSWERS

1 Nine: seven at the top and two being held by the lower figures.

2 Five: four eyes in the hieroglyphs and one on the flying creature to the right.

3 Twenty.

4 Anubis is shown twice; leading Hunefer to judgement, then weighing his heart (in the pot) against a feather. In the first case he is holding an ankh, and in the second he is holding the scales that decide Hunefer's fate.

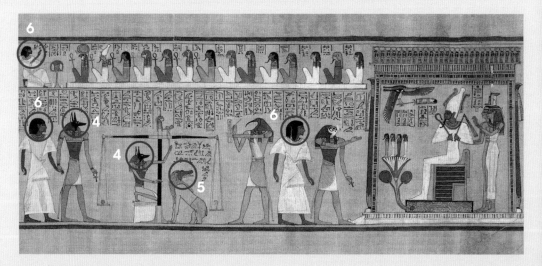

5 Part-crocodile.

6 He is shown being led to judgement, then being presented to Osiris. At the top, he is shown with a row of deities.

02

1 Fifteen: eight on angels, one on Jesus and six on people on the ground.

2 Three.

3 Four: one on the flag held high, one on a horse, one on a shield and one on body armour.

4 Eleven.

5, 6 and 7

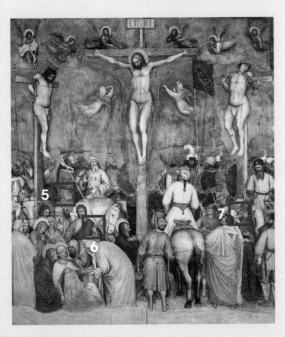

8 INRI = *Iesus Nazarenus Rex Iudaeorum* = Jesus of Nazareth, King of the Jews. The title 'King of the Jews' was used mockingly, according to the Bible.

9 SPQR stands for the Latin *Senātus Populusque Rōmānus*, or 'The Roman Senate and People'. It refers to the government of the ancient Roman Republic, and paintings of Christ's Crucifixion often feature such banners, making clear that the Roman authorities were overseeing and in charge of the execution.

1 Five. There are three horses at the left of the image – white, sandy-brown and black – and two horses pulling the chariot in the semicircle at the top.

2 Twelve. There are eleven banners held aloft by knights in the tapestry. There is another red banner hanging in front of this tapestry with motifs of fleur-de-lis, leaves and swans.

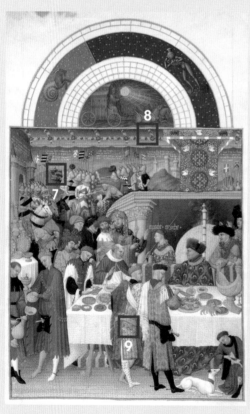

7, 8 and 9

3 Five. There are horses, swans, bears, a large dog and two small dogs on the table. There is also a mythological goat in the semicircular area at the top.

4 In a book of prayers to be said at set times of day. This image is the most famous example of French Gothic manuscript illumination.

5 When the artists and the Duke died in 1416, possibly of plague, this manuscript was left unfinished. In the 1440s an anonymous painter (possibly Barthélemy d'Eyck) worked on it, and eventually the painter Jean Colombe completed it.

6 The black belt is a weapon holder: the brown objects protruding from the belts are the hilts of 'bollock daggers', weapons commonly carried in some countries during the Middle Ages.

04

1 Three: an angel at the top left in the separate circular image, and two people just above the arch on the right-hand side.

2 The leopard's head can be seen just above the large brown horse on the right, and the lion's head is above the hand that is itself above the leopard.

3 Four: they are in the main picture, and also in each of the three smaller details in the arches. These smaller pictures represent the Magi's Biblical journey.

4, 5 and 6

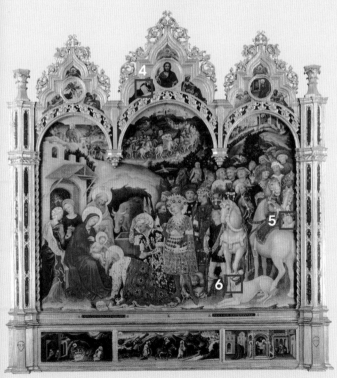

7 The lowliness of his birth.

8 Jerusalem.

9 Bethlehem.

05

1 Two: a pair of light-coloured and a pair of red shoes. These are pattens – protective overshoes that were worn outdoors over normal shoes, elevating feet above the mud and dirt in the streets.

2 The main symbol of fidelity is the dog. The single burning candle in the chandelier represents the flame of love and sanctity of marriage.

3 Four: the two main figures, plus two more people seen in the reflection in the mirror.

4 In the mirror surround, in the stained glass at the top left of the picture, and in the carpet.

5 Bruges.

6 Their rich clothing; the woman's belt, which is decorated with gold; the ornate brass chandelier; the large convex mirror; the elaborate bed-hangings; the Oriental carpet; and the oranges, an exotic food for northern Europe.

7 The beads are a paternoster, Latin for 'Our Father'. The practice of counting prayers using a string of beads is ancient, and the first prayer that medieval Christians recited using prayer beads was the 'Our Father'. Depending on a person's finances, a medieval paternoster could be a knotted string, or beads of wood, bone, glass or semi-precious stones.

8 Dog – God written backwards ('returned'), and an animal (dog).

9 Oranges – an anagram of 'nose rag' ('shaken'), and some produce (oranges).

10 Chandelier – the word 'candle' spread across the word 'heir' (Ch*AND*e*LI*E*r*), and a light fixture (chandelier).

06

1 Cupid, at the top of the picture, to show that love is blind.

2 She is scattering roses on the ground.

3 Zephyrus, on the far right, is the Greek god of the west wind. In English, 'zephyr' is a literary word meaning 'a soft, gentle breeze'.

4, 5 and 6

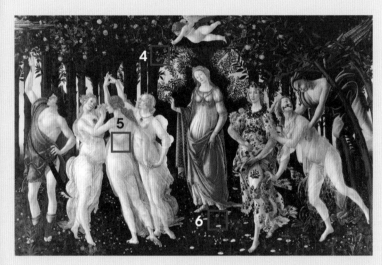

7 Dancing a roundel.

8 They represent their trade with the Far East. Oranges were also connected with medicine through their Latin name: 'mela medica', meaning 'medicinal apple'. Although never involved with medicine, the Medici encouraged this association and the balls on the family crest are thought to represent oranges.

9 Aphrodite.

10 On the right the nymph Chloris is overlapping with Flora, the goddess into whom she transforms.

1 On the left-hand side, one-third of the way up.

2 On the far left, about two-fifths of the way up.

3 Just right of centre at the very bottom; to the right of the top-left pink building; and there is also one being carried by a man halfway up on the right-hand side.

4, 5 and 6

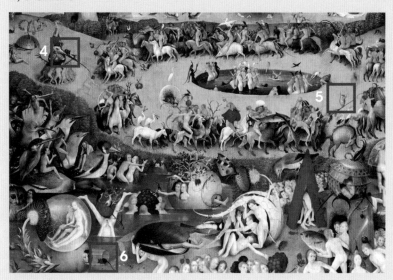

7 Butterfly – an anagram ('confused') of 'left by rut', and it is an insect.

8 Duck – a duck is a 'zero score'; 'foul' when 'said' (i.e. spoken) sounds like 'fowl'; a duck is a fowl.

9 Owl – if said quickly enough, '2 8 2 8 2 0' sounds like 'twit twit twoo', the call of an owl.

08

1 Twelve.

2 One.

3 Twelve.

4, 5 and 6

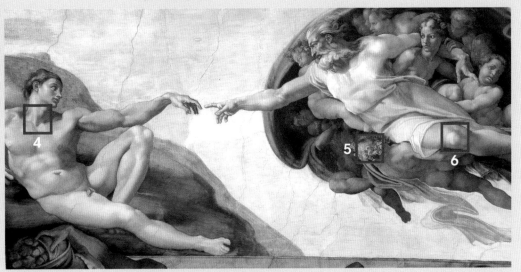

7 The Sistine Chapel in Rome, on its ceiling.

8 In 1565, after Michelangelo's death, the Council of Trent condemned the nudity of God, and Daniele da Volterra was commissioned to cover him up. As a result, Daniele was nicknamed 'Il Braghettone' ('the breeches maker').

9 The human brain.

1 In the centre, wearing red and purple.

2 In the foreground on the left, writing in a book.

3 The white statue at the top left of the picture is holding a lyre.

4 On the far right, held by the man in green; and above him, being held by the white statue.

5 The man bending over on the near right is holding a pair of mathematical compasses in his hand. He is thought to be either Euclid or Archimedes.

6 Leonardo da Vinci.

7 His dialogue, *Timaeus*.

8 His own *Nicomachean Ethics*.

9 and 10

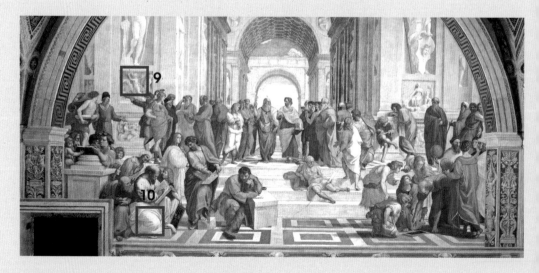

10

1. Ten: three each on two of the women, one each on two more, one on the ground and one on the small satyr.

2. Seven: two cheetahs, three snakes, a donkey and a dog.

3. Nine: four in the far background and five in the foreground. (There are also two satyrs.)

4. Three: a pair of cymbals, a tambourine and (in the distance) a horn.

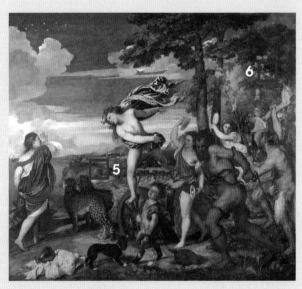

5 and 6

7. Raphael.

8. The constellation Corona Borealis (the Northern Crown), represents Bacchus's promise to marry Ariadne and transform her into a constellation.

9. To protect Ariadne from the cheetahs that are pulling it.

11

1

2

3

4

5

6

7

8

9

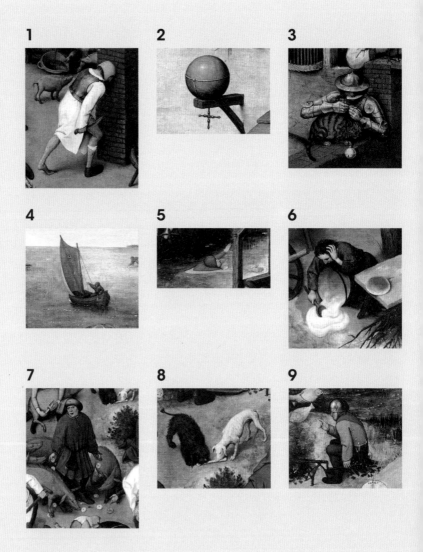

12

1 Sitting at the table, seventh from the left-hand side.

2 Sitting on the extreme left, with dark hair, dressed in red and blue, with a turban and golden cape.

3 The serving boy at the front left, dressed in red; and the poet just to the right of the musicians staring intensely at his glass.

4, 5 and 6

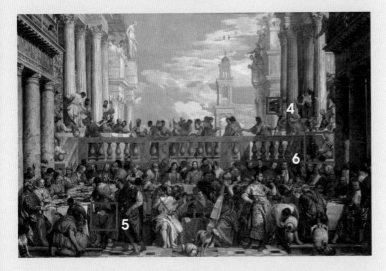

7 It is symbolic, referring to Jesus (the Lamb of God), who is sitting in the centre of the painting.

8 The man dressed in green in the foreground, to the left of the musicians.

9 It covers the largest area of any painting in the Louvre, at 667 x 994 cm (259.8 x 391 in).

1 Five or six: the one sailing away in the bottom-left corner may have been part of the bridge, but we can't be sure.

2 Ten: eight large bell decorations, and two smaller ones.

3 Twenty-three.

4 It is understood that Basāwan drew the outline of the image, but his assistant Chetar Munti painted it in colour a few years later.

5 The figure on the second, darker elephant is most likely to be Akbar, because the emperor would carry a weapon; the animal's red and gold caparison and green seat suggest a regal rider; white clothes are a sign of wealth; orange tends to indicate blessings from God.

6 He was thirteen, and reigned until his death in 1605 at the age of sixty-three.

7 Fish – in particular, the fish near the top-right of the picture. 'Skate, perhaps' clues a fish, since a skate is a type of fish, and 'fish' is already written 'in' the words 'surf is hopeless'.

8 Rope – such as the rope tied around the leftmost elephant. A 'top prelate' is the pope, and if you exchange its 'leader' (the letter 'p') for 'river' ('r'), you end up with 'rope'. Also, a 'stay, maybe' is a rope too – since a stay is a type of rope (e.g. one bracing a mast).

9 The swimmer in the sea behind the pontoon – 'he's crossing the main' is a cryptic definition of the swimmer himself (since the 'main' is the sea), while 'southwestern' is 'SW', 'one-mile' gives 'im' (1m), and the 'French sea' is 'mer'.

14

1 Two: one on the head of the old man, and one lying on the ground.

2 Jesus Christ. The angelic winged figure beside him makes it clear that Christ is heaven-sent, not a figure of this earth – and he is reaching out to save the man on the ground.

3 He is afraid, and shielding his eyes from the light. The image is inspired by the account of Paul's conversion in the Bible (Acts 9:1–19); which refers to the brightness that suddenly surrounded him.

4, 5 and 6

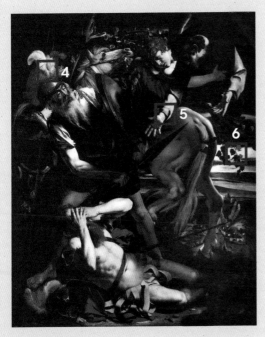

7 Saint Paul was known as Saul of Tarsus.

8 The image is one of rebirth. Paul has cast off his weapons, helmet and clothing, leaving his life of persecution of Christians behind.

9 *Chiaroscuro* – from the Italian for 'light-dark'.

15

1 Three: the feathers are blue, white and orange.

2 In the lower-middle part of the image, a gentleman can be found crouching down in front of his skating partner as she leans on him.

3 Seen near the centre of the painting, the woman is wearing a black dress with red trim, along with a white petticoat. Next to her, a man is also falling over.

4, 5 and 6

7 The flag is known as the Prince's Flag, first used in the Dutch Revolt (late 16th century), and is based on the flag of Prince William of Orange-Nassau. The modern red-white-blue Dutch flag, the Statenvlag, was used from the mid-17th century onwards.

8 The picture was originally circular, and so the square version was an extension of the original that was added by a later artist. It was later restored to its original condition.

9 The Little Ice Age, and in particular the cold winter of 1607–08.

16

1 Judith is the figure on the right, so her dress is blue with black and gold brocade. We can also see white edging, probably from undergarments.

2 Holofernes lies on a bed: in the Biblical story, he tries to seduce Judith but passes out from excessive drinking. We can see the fine detailing of the fur-trimmed blanket and bedsheets wrapped around him.

3 Holofernes is semi-awake. Passed out in a drunken stupor – his eyes are still open and he is weakly grasping at the maid's clothing, unable to defend himself.

4, 5 and 6

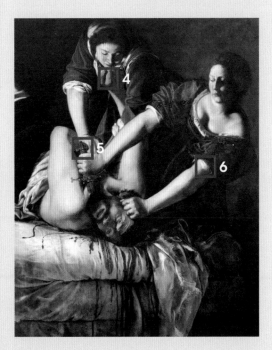

7 *Chiaroscuro* (play of dark and light).

8 The artist Artemisia Gentileschi drew herself as Judith. She painted Holofernes as her mentor Agostino Tassi, who was tried for and convicted of her rape.

9 The decapitated head of Holofernes.

1 Twenty.

2 They are eating with chopsticks.

3 Five: two round tables can partly be seen in the background inside the inner porch; two large retangular tables in the midground; and one small low-to-the-ground table to the right side of the porch beside the women sitting on the ground.

4, 5 and 6

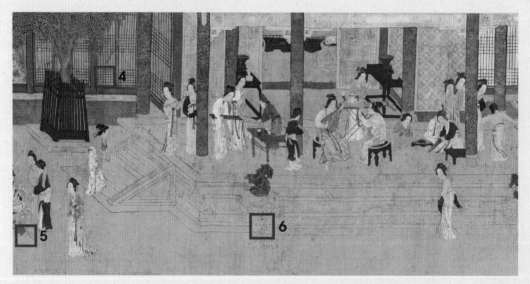

7 The Ming Dynasty.

8 206 BCE–220 CE.

9 She refused to bribe the artist to paint her to look beautiful, as the other concubines had – and so, out of spite, he made her look ugly.

18

1 Eleven: the Infanta; the two maids of honour on each side of her; the chamberlain on the steps; then, looking to our right, an older woman (chaperone) and male bodyguard; and the two dwarfs behind the dog. On the left are Velázquez himself and, in the mirror beside him, reflections of the king and queen.

2 At the back of the room there is an open door, allowing in a secondary source of light.

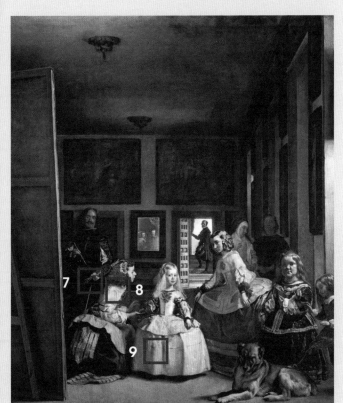

3 The maid on the left is wearing a butterfly brooch in her hair.

4 Velázquez has painted the artist as himself.

5 Philip IV and Mariana of Austria, who are reflected in the mirror.

6 The painting was damaged in a fire, and was restored by court painter Juan García de Miranda.

7, 8 and 9

1 They are drawn with many imperfections, including various stains, cracks, shadowing, nails and nail holes, in an incredibly realistic way.

2 The brown box is a foot warmer.

3 While the milkmaid herself appears to be concentrating on her work, there is a suggestion that her downcast eyes are more wistful. She is dressed conservatively, but the clothing fits her snugly, emphasising her curves. There are images of Cupid in the tiles near the floor, and foot warmers were often used in paintings to suggest a carnal heat in female subjects. Wide-mouthed jugs were also used as a symbol of the female anatomy.

4 Some historians think the woman is making bread pudding, which accounts for the bread pieces on the table along with the milk.

5 Vermeer originally painted a large clothes basket behind the milkmaid, an image that was eventually rediscovered via X-ray analysis. It is thought that he removed it to offer better focus on the subject of the image.

6 *The Kitchen Maid.*

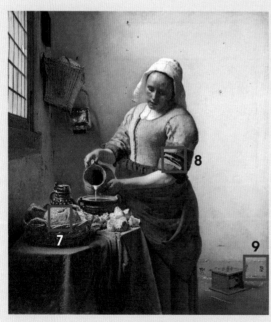

7, 8 and 9

20

1 He is holding his hands up in surrender – there are also echoes of the Crucifixion in his pose.

2 Two.

3 The French are painted from the back, so we do not see their faces. This renders them unknown and unrecognisable, which makes them even more frightening.

4, 5 and 6

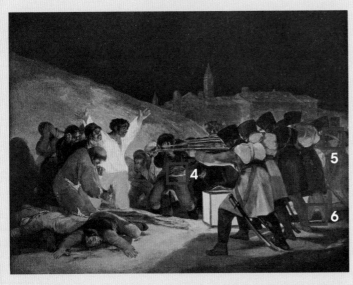

7 Kenneth Clark (1903–1983), the author, broadcaster and art historian most famous for his TV series *Civilisation* (1969).

8 The companion piece was called *The Second of May 1808*, and it depicted the Dos de Mayo Uprising, one of the many Spanish rebellions against French occupation.

9 Napoleon Bonaparte, who started to take control of multiple regions of Spain. The Spanish king, Charles IV, abdicated in favour of his son Ferdinand VII. Both were invited to France by Napoleon, who forced both Spaniards to abdicate so that he could make his brother, Joseph, Spain's new king.

1 Fifteen.

2 Nine.

3 The riverbanks, combined with the bridge, look like a Z.

4 The black stakes in the water near the shore (known as
Hyappongui, meaning 'Hundred Stakes') were designed
as a breakwater to protect the bank from the fast current
as the river curved eastward.

5 The Tōkaidō road ran between Edo and Kyōto, and was the
most important of the five major roads in Japan.

6 Ukiyo-e means 'pictures of the floating world'. The 'floating
world' refers to the pleasure districts of Edo.

7 The area in the bottom part of the picture depicts a row of
riverside tea stalls, similar to those found in a modern Tokyo
coffee shop. The area pictured is still occupied by a number
of cafés and restaurants today.

8 Kyōto ceased to be the capital in 1869, when the imperial
court transferred to Tokyo.

9 Honshū.

22

1 Three figures: one in the foreground, and two on the stairs towards the rear of the picture.

2 Monet's palette was white, and warm and cool versions of yellow, green, blue and red.

3 The intricate combination of shadow and light on the ground is used to give the garden depth. Combined with the size of the figures in the garden and the sloping of the ground and path, this gives the garden a sense of scale and perspective.

4, 5 and 6

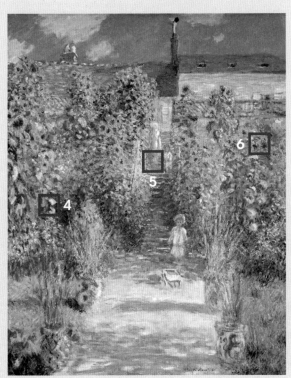

7 Orange gladioli.

8 The best known examples are his paintings of haystacks (1891), poplars (1892), Rouen Cathedral (1892–94), and of water lilies (1900–20).

9 The child in the foreground is Monet's son Michel.

1 Six: four to the left, two to the right.

2 She is the barmaid also seen in the centre of the image, reflected in a mirror. The perspective is unusual.

3 The feet of the trapeze artist can be seen dangling down in the top-left corner of the painting.

4 This is considered Manet's last major work.

5 The composer Emmanuel Chabrier (1841–94) owned this painting, and hung it over his piano.

6 German beer would often have been seen in a French bar – but the two bottles of ale here are ostentatiously English (Bass Pale Ale), reflecting anti-German feeling at the time.

7, 8 and 9

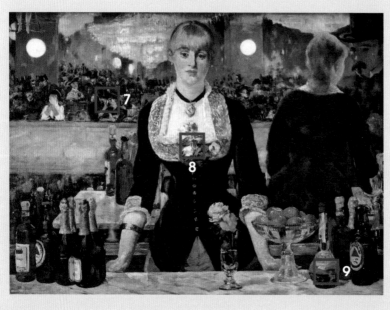

24

1. The monkey is at the feet of the woman on the right of the painting.

2. There are seven open parasols in the painting, and one folded on the ground beside the girl holding the flowers, making eight in total.

3. Three: sailing boats, rowing boats and steamers can be seen.

4. The painting technique is called pointillism.

5. *A Sunday on La Grande Jatte* marked the beginning of the Neo-Impressionist movement.

6. The Topiary Park is in Columbus, Ohio. The sculptor James T. Mason began the work in 1989 and completed it in 1992.

7. Historians think these two women may have been prostitutes.

8 and 9

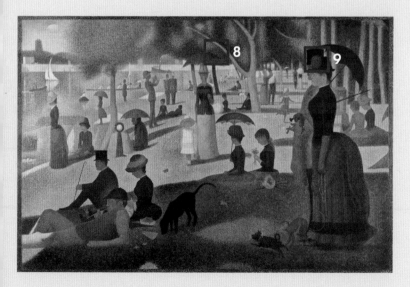

1 Twelve, one of which is the moon (top-right corner).

2 Nine. They are painted yellow, suggesting lights within.

3 The body with the brightest, whitest halo, nearest the horizon, is Venus, which is also known as the evening star.

4 After Van Gogh famously cut off his own left ear, he voluntarily admitted himself to the Saint-Paul de Mausole asylum at Saint-Rémy, where he painted *The Starry Night*.

5 Cypress trees usually symbolise death in European culture.

6 The artist shot himself, but the injury was not itself fatal; he died as a result of an untreated infection in the wound.

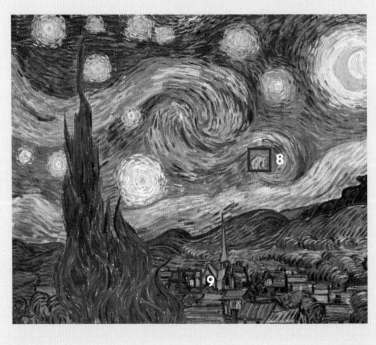

7 Theo van Gogh, the artist's brother and long-time correspondent, died just a few months after him. Initially buried in Utrecht, his body was exhumed in 1914 and reburied beside Vincent's at Auvers-sur-Oise.

8 and 9

26

1. Degas – he encouraged Valadon to paint, and so she included one of his paintings in her own.

2. There are some holly sprigs in a vase. In the glass in front of it, there are some white carnations and a purple flower, perhaps a hydrangea.

3. Three. The mother wears earrings (though only one can be seen) and a necklace, and Gilberte wears a necklace.

4 and 5

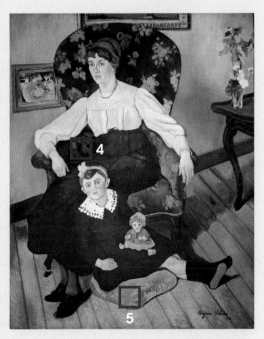

6. The Société Nationale des Beaux-Arts, a society of French artists who worked collaboratively to hold exhibitions.

7. She was married twice: firstly to stockbroker Paul Mousis, then to painter André Utter, who was 23 when she met him at the age of 44.

8. She appears in several, including *Girl Braiding her Hair, Dance at Bougival, The Umbrellas, Dance in the City*.

9. Valadon's son was the painter Maurice Utrillo (1883–1955).

1 There are ten complete boxes: one large red, one medium yellow, one medium dark blue, one medium black, one small black, two small grey, three small white.

2 White – it covers slightly more area in total than the red does.

3 Thirteen strokes: seven horizontally (where one stroke runs through the black area) and six vertically.

4 Mondrian founded the De Stijl art movement group with Theo van Doesburg. Their art used the essentials of form and primary colours, simplifying images to use black, white and colour in simple vertical and horizontal compositions.

5 Cubism.

6 In 1938, as Fascism gained strength in Europe, Mondrian moved to London, where contemporary artists such as Ben Nicholson and Naum Gabo were working.

7 Option C.

C

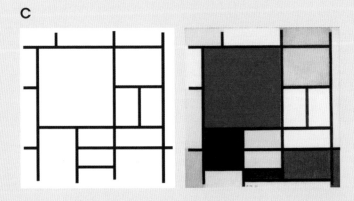

28

1 The flags are those of France, Catalonia and Spain. They
 are likely to refer to Catalonia's desire to secede from
 Spanish rule, as is suggested by the placement of the French
 and Catalan flags together, across the border from the
 Spanish one.

2 Surrealism – this is one of Joan Miró's first Surrealist
 paintings.

3 Identifiable creatures in this painting include the chicken,
 snail, lizard and rabbit (bottom right), the dog and horses
 (centre), and bull (right). There are also birds in the sky.

4 These lines are likely to represent the tilled field(s) referred
 to in the painting's title.

5 The word 'jour', meaning 'day' in French, can be seen on the
 newspaper to the bottom right of the horse.

6 The sky, sea and the earth.

7 Miró grew up in Catalonia, a region in the northeast of Spain
 which has its own distinct culture and language.

8 Miró believed that everything was alive and magical, and
 giving the tree human properties such as eyes and ears
 shows that it has senses of its own.

9 The muted colours are reminiscent of Catalan Romanesque
 frescoes. This painting combines different artistic themes to
 suggest simpler, more idyllic times.

1 There is a stigma (a mark corresponding to Christ's Cruxifiction wound) on the hand of the fallen soldier (bottom left).

2 A man lies on the ground, clutching a broken sword. There is also what appears to be a flower growing from his hand, perhaps signifying new growth after destruction.

3 There is a bull (left), a horse (centre) and a dove (drawn onto the back wall).

4 The lack of colour intensifies the image and the dramatic, chaotic movement within it. In particular, it helps to suggest the look of the newspaper from which Picasso had first learned of the atrocity.

5 Picasso painted this in response to the Nazis' bombing of the town of Guernica in 1937 during the Spanish Civil War. The bull is thought to represent rising Fascism as well as Spain itself.

6 She made a full-size tapestry of Guernica. It currently hangs at the Headquarters of the United Nations in New York City. It was commissioned by Nelson Rockefeller after Picasso refused to sell him the original.

7 Guernica is a Basque town on the northern coast of Spain, just east of Bilbao.

8 Paris.

9 Twenty three! Picasso was baptised 'Pablo Diego José Francisco de Paula Juan Nepomuceno María de los Remedios Cipriano de la Santísima Trinidad Martyr Patricio Clito Ruíz y Picasso.'

30

1 There is a black and white chequered board, which could be a chess or draughts board.

2 Eight naked figures group in the area between Narcissus and the hand, plus the naked figure of Narcissus on the red and black plinth on the game board. Also, eggs are traditionally a symbol of sex and fertility.

3 There are eleven ants crawling on the hand, with more scurrying around the base of it.

4 He paints the hand, egg and flower in a structure that mimics the pose of Narcissus, creating a double image that makes us look more closely at both its iterations.

5 Because he is in love with his own reflection.

6 Dalí wrote a poem that was originally exhibited alongside the painting.

7 Dalí met Sigmund Freud in London in 1938, and he brought *Metamorphosis of Narcissus* with him as a sample of his work.

8 Critical paranoia.

9 A pet ocelot (wild cat) named Babou.

1 Four.

2 There are three complete circles: the black, white and yellow ones stacked one on top of another in the top third of the painting.

3 Five: two semicircles and three arcs.

4 Complementary colours are colours that oppose one another in a colour wheel by forming physical inverses of one another. Within the painting, the complementary colours blue and orange are placed together in a number of different areas.

5 Sonia Delaunay was born in Ukraine, and the colours and patterns of Ukrainian folk art are used in the image.

6 Delaunay and her husband Robert founded Orphism.

7 Delaunay's *Coccinelle* was featured on a stamp released by France's La Poste and the United Kingdom's Royal Mail.

8 Sara Élievna Stern, which is occasionally alternatively spelled Sarah Ilinitchna Stern. She took the name Sofia Terk after her aunt and uncle who took care of her, even though they never officially adopted her, but she was nicknamed Sonia rather than Sofia, which she apparently liked. Later, she took her husband's surname.

9 The exhibition at the Louvre was the gallery's first retrospective of a living female artist.

32

1 Seven: one monkey, one black cat, one hummingbird, two butterflies and two fantastical dragonflies.

2 The thorns are reminiscent of Christ's crown of thorns. We see them digging into Kahlo's skin, making her bleed.

3 Black cats are sometimes considered a sign of bad luck.

4 While the black cat is a symbol of bad luck, the dead hummingbird hanging from Kahlo's neck is a charm for good luck, according to Mexican folklore.

5 Frida Kahlo's husband was Diego Rivera, a prominent Mexican painter who was twenty years her senior, and had two wives before he married Frida. He and Frida were married twice, between 1929–39 and 1940–54.

6 The pendant is a symbol of the Aztec god of war, Huītzilōpōchtli.

7 Kahlo is seen in the 2017 animated feature film *Coco*. It is set in Mexico and packed with nods to Mexican culture.

8 After an exhibition in Paris, the Louvre purchased Kahlo's self-portrait *The Frame* in 1939.

9 On 17 September 1925, Kahlo was involved in a bus crash which killed several people and fractured her ribs, legs and collarbone. Kahlo then had bronchopneumonia prior to her death. While the official cause of death was pulmonary embolism, biographer Hayden Herrera argued that Kahlo overdosed on her medication and committed suicide. Other scholars have speculated that she may have accidentally overdosed on painkillers.

33

1 There are sixteen figures.

2 Three. Two are double-sided, and one at the top runs in both horizontal and vertical planes.

3 Seven. There are four to the outside of the building which let light in, plus a semi-arch towards the centre of the image. We also have glimpses of light from the courtyard areas (top centre and bottom right).

4 A basket, a book, a sack, a tray with a bottle and a glass, cutlery, bannisters and another figure.

5 Three.

6 In the top third of the image, there is a staircase that stretches horizontally. There are two figures here who appear to walk on different planes.

7 The first version was a woodcut, also created in 1953.

8 In *Night at the Museum: Secret of the Tomb* (2014), these three characters experience the warped gravity featured in the image.

9 Andrew Lipson and Daniel Shiu recreated the image using Lego® bricks and sixteen identical Lego® figures.

34

1 Venus appears twice and so does her reflection.

2 A bald eagle: the national bird of the USA.

3 The black-and-white image shows plans regarding a moon mission. This may represent the US mission with *Ranger 7*, which successfully took place in 1964.

4 Rauschenberg wanted the viewer to feel the fast pace of evolving American popular culture.

5 Six. The stop sign, plus three blue signs above it, and then a one-way sign above the black-and-white man at the bottom-left. There is also a very small sign above the traffic light in the middle of the artwork.

6 Pop art and Neo-Dada. Rauschenberg is usually categorised as being one of the most influential artists of the Neo-Dada movement.

7 Andy Warhol. Rauschenberg met him in 1962 at his studio, which was when he first saw the silkscreen technique.

8 Abstract Expressionism was popular in America in the post-World War Two years, and focused on spontaneous, subconscious creation. Neo-Dada and Pop art pushed back against these abstract images and concepts by instead manipulating the imagery of mass media.

9 NASA invited Rauschenberg to watch the launch of *Apollo 11*. He subsequently created a series of lithographs called the *Stoned Moon Series*.

35

1　Two. One above his right elbow, and one to the left of his halo.

2　There is a golden halo above the figure's head, which could be interpreted as angelic. The red spikes around it may also reference Christ's crown of thorns. Red blood appears to be pouring from his hands, as if they've been nailed to a cross.

3　Five: pale pink, deep pink, brown, red and black.

4　Basquiat was part of a notable graffiti team, SAMO, who painted epigrams around the Lower East Side of Manhattan in the late 1970s.

5　*The New York Times Magazine*.

6　Matilde Basquiat, Jean-Michel's mother, noticed her son's artistic ability and took him to exhibitions, enrolling him as a junior member of the Brooklyn Museum.

7　*Downtown 81*, a 'verité' film also known as *New York Beat Movie*. Basquiat played a struggling artist.

8　Basquiat was known for wearing expensive Armani suits with bare feet, which was how he appeared on the cover of *The New York Times Magazine* in 1985. He also worked in these suits, and often appeared with them splattered in paint.

9　Keith Haring (who was the creator of the next artwork in this book).

36

1 Nine.

2 Five: green, pink, yellow, orange and black.

3 The black lines suggest movement, making the picture feel alive and exciting. It looks like it is buzzing with energy.

4 To show that people are all connected. Haring is exploring the unity of humanity, despite the differences that individuals might experience – such as gender or illness.

5 It was a symbol Haring used to represent individuality.

6 Madonna donated the proceeds of the first New York date of her *Blond Ambition* world tour to Haring, as documented in her film *Truth or Dare*. She later used his work to create animated backdrops for her 2008/2009 *Sticky and Sweet* tour.

7 Grace Jones. In 1984 Haring painted Grace Jones's body in his signature style. Warhol arranged for Robert Mapplethorpe to photograph the body painting once complete.

8 Lacoste, which premiered its 'Keith Haring x Lacoste' range.

9 Haring decorated a section of the Berlin Wall with a bright, figurative mural. He used red, yellow and black, the colours of the German flag, to symbolise the hope that East and West might be reunited.

Index

A Bar at the Folies-Bergère by Manet 96–99

A Pile of Crowns for Jean-Michel Basquiat by Keith Haring 147

A Sunday on La Grande Jatte by Seurat 100–103

A Winter Scene with Skaters near a Castle by Avercamp 64–67

Abstract Expressionism 187

Adoration of the Magi by Gentile da Fabriano 20–23

Aerial perspective 64

Akbar I (Akbar the Great) 56, 57, 59

Akbar's Adventures with the Elephant Hawa'i by Basāwan and Chetar Munti 56–59

Albers, Josef 140

Alexamenos graffito 12

Alfonso d'Este, Duke of Ferrara 44

Alhambra, Palace of the 136

Altamira, Spain 117

Altichiero da Verona 13

Apollinaire, Guillaume 128

Arnolfini, Giovanni di Nicolao 25

Art Institute of Chicago, Illinois 101

Automatism 116

Auvers-sur-Oise 107

Avanzi, Jacopo 13

Avercamp, Hendrick 64, 65, 67

Bacchus and Ariadne by Titian 44–47

Basāwan 56, 57, 166

Basquiat, Jean-Michel 144, 145, 147

Basquiat, Matilde 188

Bass (beer/brewery) 96, 176

Bassano, Jacopo 53

Belle painting 73

Berlin Wall 189

'Black Paintings' by Goya 84

Bonaparte, Joseph 173

Bonaparte, Napoleon 124, 173

Bosch, Hieronymus 32, 33, 117

Botticelli, Sandro 28, 29

Bramante, Donato 40, 41

British Museum, London, 9

Brooklyn Museum of Art, New York 89, 188

Bruegel the Elder, Pieter 48, 49

Bruegel the Younger, Pieter 48

Caravaggio, Michelangelo Merisi da 60, 61, 63, 69, 71

Cenami, Giovanna 25

Chabrier, Emmanuel 176

Charles IV, King of Spain 173

Chetar Munti 57, 166

Chevreul, Michel-Eugène 129

Chiaroscuro 167, 169

Clark, Kenneth 173

Cloisonnism 109

Coca, Marie 109

Coccinelle by Delaunay 131, 184

Coco (film) 185

Colombe, Jean 156

Composition with Large Red Plane, Yellow, Black, Grey and Blue by Mondrian 112–115

Courtauld Gallery, London 97

Creation of Adam by Michelangelo 36–39

Crucifixion by Altichiero da Verona 12–15

Cubism 128, 129, 131, 180

d'Eyck, Barthélemy 156

Dalí Salvador 76, 124, 125, 127, 183

Dallas Museum of Art, Texas 141

Dance at Bougival by Renoir 179

Dance in the City by Renoir 179

Daniele da Volterra 161

De la Baume Dürrbach, Jacqueline 123

De Stijl ('The Style' – Dutch art movement) 113, 180

Degas, Edgar 109, 179

Delaunay, Robert 128, 184

Delaunay, Sonia 128, 129, 131, 184

Downtown 81 (film), a.k.a. New York Beat Movie 188

Edo period 88

Escher, Maurits Cornelis (M.C.) 136, 137

Ezekiel, Book of 117

Fauvism 129

Ferdinand VII, King of Spain 173

Freud, Sigmund 183

Furious Man by Basquiat 144–147

Gabo, Naum 180

Galleria degli Uffizi, Florence 21, 29

García de Miranda, Juan 171

Gauguin, Paul 109

Gemäldegalerie, Staatliche Museen zu Berlin 49

Gemeentemuseum Den Haag, The Hague 113

Genesis, Book of 105

Gentile da Fabriano 20, 21

Gentileschi, Artemisia 68, 69, 71

Gentileschi, Orazio (father of Artemisia) 68, 69

Gilberte (daughter of Marie Coca) 109, 179

Giotto 13

Girl Braiding her Hair by Renoir 179

Goya, Francisco de 84, 85, 87

Gray's Anatomy 145

Guernica by Picasso 120–123

Han Dynasty 72, 73, 75

Haring, Keith 148, 149, 151, 188, 189

Harry Ransom Center, University of Texas, Austin 133

Henry V, King of England 16

Herrera, Hayden 185

Hiroshige. Utagawa (Andō) 89, 91

Hsiang Yuan-pien 72

Infanta Margarita 77

January, from *Les Très Riches Heures du Duc de Berry* by the Limbourg brothers 16–19

Johnson, Philip 141

Judith Slaying Holofernes by Artemisia Gentileschi 68–71

Kahlo, Frida 132, 133, 135, 185

Kennedy, President John F. 141

Lacoste 189

Las Meninas by Velázquez 76–79

Last Judgement of Hunefer from the *Book of the Dead* 8–11

Limbourg brothers (Herman, Paul, Jean) 17, 19

Lipson, Andrew 139, 186

Manet, Édouard 76, 97, 99, 176

Mapplethorpe, Robert 189

Mariana of Austria 77, 171

Maribárbola (Maria Bárbola) 77

Mason, James T. 177

Medici family 31, 69, 159

Metamorphosis of Narcissus by Dalí 124–127

Michelangelo Buonarroti 36, 37, 41, 161

Ming Dynasty 73, 170

Miró, Joan 116, 117, 119, 181

Mona Lisa by Leonardo da Vinci 120
Mondrian, Piet 112, 113, 115, 180
Monet, Claude 92, 93, 95, 175
Monet, Michel 175
Mont-roig del Camp, Catalonia 117
Mousis, Paul 179
Musée Condé, Chantilly, France 17
Musée des Beaux-Arts, Lyon, France 109
Musée du Louvre, Paris 53, 165, 184, 185
Musée National d'Art Moderne, Centre Georges Pompidou, Paris 129
Museo Nacional Centro de Arte Reina Sofía, Madrid 121
Museo Nacional del Prado, Madrid 33, 77, 85
Museo Nazionale di Capodimonte, Naples 69
Museum of Modern Art, New York 105, 137
Mussolini, Benito 28

National Gallery of Art, Washington, D.C. 80, 93
National Gallery, London 25, 45, 65
Neo-Dada 187
Neo-Impressionist movement 177
Neo-Plasticism 113
Netherlandish Proverbs by Bruegel the Elder 48–51
Nicholson, Ben 180

Odescalchi Balbi Collection, Rome 61
One Hundred Views of Edo 89
Oratorio di San Giorgio, Padua 13
Orphism 128

Papal Palace, Vatican 41
Pertusato, Nicolás (Nicolasito) 77
Philip IV, King of Spain 69, 76, 77, 171
Picasso, Pablo 76, 120, 121, 123, 182
Pointillism 177
Pop art 187
Pop Shop, Manhattan 148
Pope Julius II 36
Portrait of Marie and Gilberte by Valadon 108–111
Post-Impressionism 129
Pre-Raphaelites 40
Primavera by Botticelli 28–31
Puvis de Chavannes, Pierre 109

Qiu Ying 72, 73, 75

Raphael 36, 40–41, 43, 163
Rauschenberg, Robert 140, 141, 143, 187
Relativity by Escher 136–139
Renoir, Pierre-Auguste 109, 111
Rijksmuseum, Amsterdam 81
Rivera, Diego 133
Rockefeller, Nelson 182
Rubens, Peter Paul 141
Ruler-lined painting 73
Ryōgoku Bridge and the Great Riverbank by Hiroshige 88–91
Rythme 38 by Sonia Delaunay 128–131

Saint Laurent, Yves (*Mondrian Collection*) 112
Saint Peter's Basilica, Rome 41
Saint-Paul de Mausole asylum, Saint-Rémy 104, 105, 178
Salon des Tuileries, Paris 129
SAMO (graffiti team) 188
San Giorgio Maggiore church, Venice 52
Self-Portrait with Thorn Necklace and Hummingbird by Kahlo 132–135
Seurat, Georges-Pierre 100, 101, 103
Shiu, Daniel 139, 186
Simultanism 128
Singer Sargent, John 76
Sistine Chapel, Vatican City, Rome 37
Skyway by Rauschenberg 140–143
Société Nationale des Beaux-Arts 108, 179
Solomon R. Guggenheim Museum, New York 117
Song Dynasty 73
Spanish Civil War 121
Spring Morning in the Han Palace (after Qiu Ying) 72–75
Stanza della Segnatura, Vatican, Rome 41
Stoned Moon Series by Rauschenberg 187
Surrealism 117, 124, 132, 181

Tang Dynasty 73
Tassi, Agostino 68
Tate Modern, London 125
The Arnolfini Portrait by Van Eyck 24–27
The Artist's Garden at Vétheuil by Monet 92–95
The Birth of Venus by Botticelli 28
The Conversion of Saint Paul by Caravaggio 60–63

The Frame (Kahlo self-portrait) 185
The Garden of Earthly Delights by Bosch 32–35
The Kitchen Maid (alternative name for Vermeer's The Milkmaid) 172
The Milkmaid by Vermeer 80–83
The School of Athens by Raphael 40–43
The Second of May 1808 by Goya 173
The Starry Night by Van Gogh 104–107
The Third of May 1808 by Goya 84–87
The Tilled Field by Miró 116–119
The Umbrellas by Renoir 179
The Wedding Feast at Cana by Veronese 52–55
Theosophy 113
Tintoretto 53
Titian 44, 45, 47, 53
Tomassoni, Ranuccio 60
Topiary Park, Columbus, Ohio 177
Toulouse-Lautrec, Henri de 109
Tree of Life by Keith Haring 148–151
Trenta, Costanza 25
Trotsky, Leon 132

Ukiyo-e 88, 92, 174
United States Pavilion 141
Untitled by Jean-Michel Basquiat 144
Utrillo, Maurice 179
Utter, André 179

V&A Museum, London 57
Valadon, Suzanne 108, 109, 111, 179
Van Doesburg, Theo 115, 180
Van Eyck, Jan 24, 25
Van Gogh, Theo 104, 105, 178
Van Gogh, Vincent 104, 105, 107, 178
Van Gogh-Bonger, Johanna (wife of Theo van Gogh) 104
Velázquez, Diego 76, 77, 79
Venus in Front of the Mirror by Rubens 141
Vermeer, Johannes 80, 81, 83, 172
Veronese, Paolo 52, 53
Vespucci, Simonetta 28

Walters Art Museum, Baltimore 73
Wang Zhaojun 75
Warhol, Andy 141, 151
Wimmelbilder images 49
World's Fair (New York, 1964) 141

Yuandi (Chinese emperor) 75

About the Authors

Susie Hodge MA FRSA has written over 100 books on art, art history, history and artistic techniques, including the bestselling *Why Your Five Year Old Could Not Have Done That*, *The Short Story of Art* and *How to Survive Modern Art*. In addition she hosts lectures, talks and practical workshops, and regularly appears on television and radio talks and documentaries on everything to do with art.

Dr Gareth Moore is the author of over 200 puzzle and brain-training titles for both children and adults, including *The Ordnance Survey Puzzle Book* (Trapeze), *Enigma: Crack the Code* (Michael O'Mara) and *The Penguin Book of Puzzles* (Michael Joseph). His books have sold in excess of 5 million copies in the UK alone, and have been published in over 35 different languages. He is also a director of the World Puzzle Federation, which oversees the World Puzzle Championships, and a director of the UK Puzzle Association. Find him online at www.DrGarethMoore.com.

Picture Credits